ART FOR OBAMA

Designing *Manifest Hope* and the Campaign for Change

Edited by Shepard Fairey & Jennifer Gross

ABRAMS IMAGE • NEW YORK

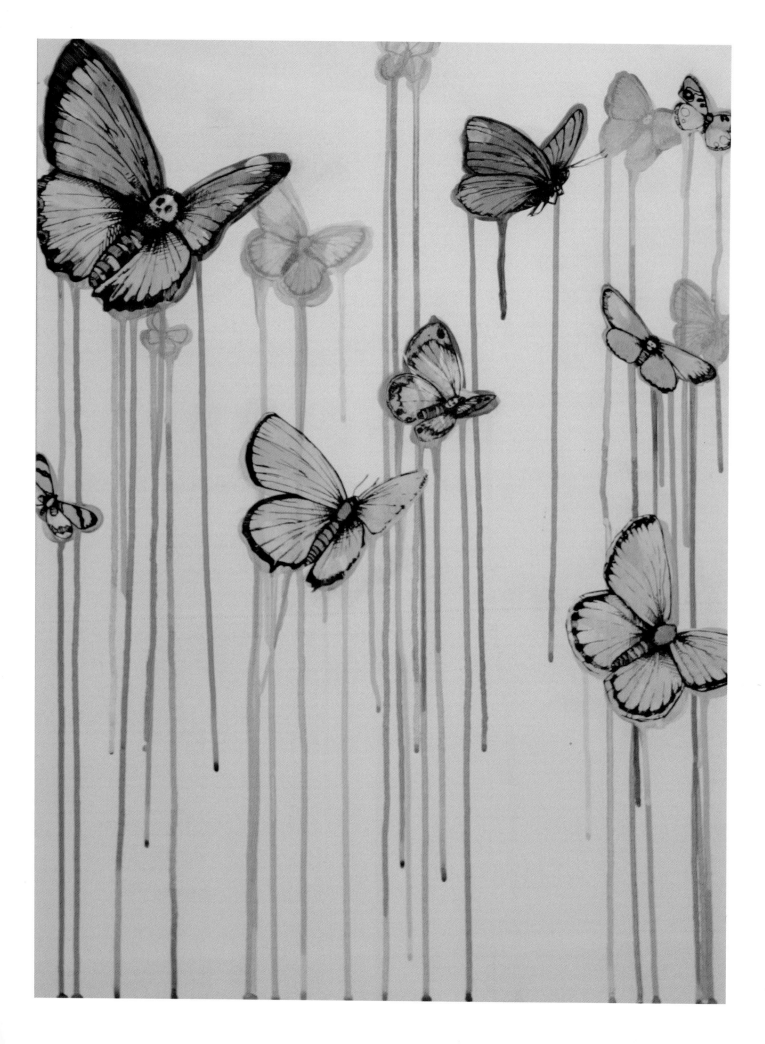

CONTENTS

Sage Vaughn
Inevitable Change, **2009**
Mixed Media and oil-based
paint on paper
22 x 30"

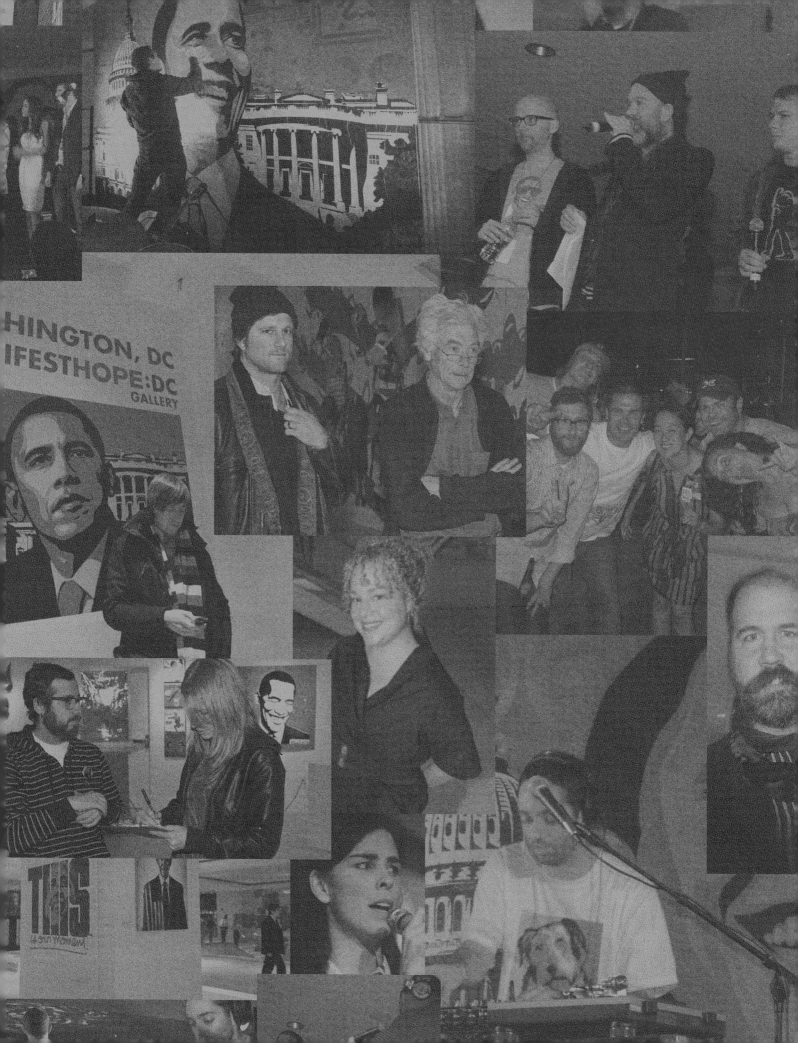

MAKING CHANGE

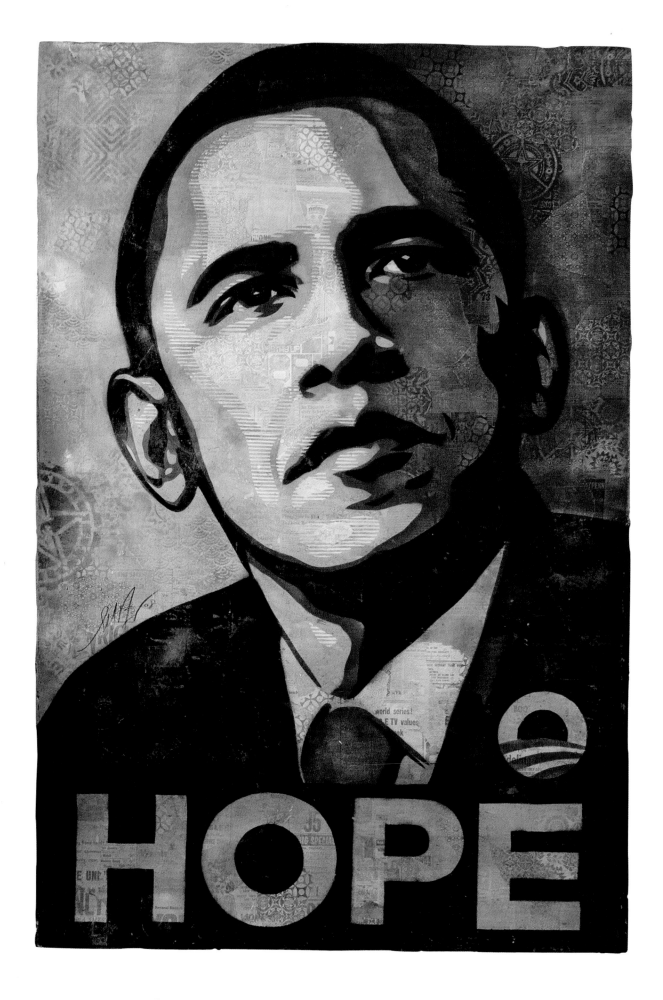

THE BIRTH OF HOPE

SHEPARD FAIREY

From the moment I first heard Barack Obama speak, I was impressed. It was at the Democratic National Convention in 2004, where he delivered the keynote address and spoke about uniting America and creating opportunities for everyone to prosper. He also spoke about combating the politics of cynicism and despair with a new kind of politics—politics of hope and progress. I did a bit of research and found that he had opposed the war in Iraq from the beginning, and as a senator he wanted to reduce the power of lobbyists in Washington. I'm a strong advocate of both of those views, and I make a lot of art addressing various political and social issues, so when Obama announced in 2007 that he was running for president, I knew I wanted to make art to support him.

But unlike with most of my posters, where I make my commentary without consulting anyone first, this time I hesitated. I'm a street artist who's been arrested fifteen times, and I didn't want to be a liability to Obama's cause. I didn't want him to be seen as too radical or too outside the mainstream just because someone like me chose to support him. Around Halloween, I asked my friend Yosi Sergant, who had some connections in the Obama campaign, to see how they'd feel about my support. A few months later, with just a couple weeks to act before Super Tuesday (February 5, 2008, when twenty-two states held Democratic primary elections), I received word that the campaign was cool with my plans. With so much at stake on Super Tuesday, I knew I had to act quickly or the window of opportunity to make an impact for Obama might be missed.

As an artist, the things that really struck me about Obama were his sincerity and idealism. Through his speeches, he seemed to inspire people to think about what this country could be, how we should all strive to live up to the ideals of the founding fathers: that everyone is created equal, and is equally entitled to life, liberty, and the pursuit of happiness. When I made the *Hope* portrait, I wanted to capture his idealism, vision, and his contemplative nature, this last one of the most easily overlooked qualities that a strong leader embodies. Of course leaders need to be decisive, but to solve difficult problems they also need to be able to navigate so many complex variables in order to unite people and make things happen. With my illustration, I wanted to convey that Obama had vision—his eyes sharply focused on the future—and compassion, that he would use his leadership qualities for the greater good of America in a very patriotic way. I used a photo for reference (which is now the subject of a legal dispute), and gave the illustration a patriotic color scheme, dividing the face into the red shadow side and the blue highlight side, to convey the idea of blue and red states, Democrats and Republicans, who are frequently in opposition, converging.

I put my Obama illustration to work as a grassroots tool in the same way I would any of my work: I made the image, posted it online (including a high-resolution download), and printed up posters and stickers, which I started putting up around L.A. and sending out to other parts of the country. Very quickly, a lot of people,

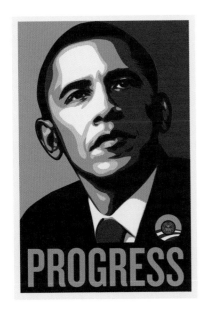

ABOVE
Shepard Fairey
Obama Progress, **2008**
Screen print on paper
18 x 24"
(Reference for Hope *and* Progress
illustrations: Mannie Garcia)

OPPOSITE
Shepard Fairey
Obama Hope Stencil, **2009**
Spray paint stencil
and collage on paper
36 x 48"

including many from the Obama campaign, started using the jpeg of my image as their email signature and their MySpace or Facebook profile image. Then I got a call from Scott Goodstein, from the digital side of Obama's campaign, and he said, "Hey, your poster's really great. Would you be interested in designing something like that for the campaign that we can sell on the Web site to raise money and use as a promotional tool on posters and stickers?" I was very happy to do that, so I donated another couple illustrations to them for that purpose. Toward the end of that month, I received a letter from Barack Obama thanking me for making the *Hope* portrait:

Dear Shepard,

I would like to thank you for using your talent in support of my campaign. The political messages involved in your work have encouraged Americans to believe they can help change the status quo.

Your images have a profound effect on people, whether seen in a gallery or on a stop sign. I am privileged to be a part of your artwork and proud to have your support. I wish you continued success and creativity.

Sincerely,
Barack Obama

I couldn't have given him better words to describe what I was trying to accomplish with my art and the portrait. I was amazed that he took the time to write a thank-you letter, and that he recognized the power of an art piece. As time went on, his campaign—and people across the country—began to realize that there was a real interest in using works of art as symbolic tools. Slogans are great and the logo for Obama's campaign was great, but there's something about a portrait that conjures feelings about a person in a much more visceral way. For someone with a magnetic personality like Obama's, a portrait carries a euphoric association with his charisma that can't be replicated with typical campaign materials.

Most politicians come across as used-car salesmen willing to say anything to get a vote, and for that reason few of them ever inspire young people—or art. A lot of young people have felt completely alienated from the two-party system of democracy, because they don't trust or relate to the politicians they see. Obama has the unique quality of being able to inspire people without shying away from talking about difficult obstacles. He captures an ideal, but he also has a realism and a down-to-earth sincerity that I think is unusual. A lot of artists reacted positively to him because the two things that artists really respond to and relate to—and which should be the essence of art—are authenticity and idealism.

One of the most remarkable things about the grassroots art movement surrounding Obama's campaign was that, for the first time since maybe the sixties, there was a genuine movement where artists felt like there was an opportunity to

<u>Barack Obama</u>

February 22, 2008

Shepard Fairey

Dear Shepard,

I would like to thank you for using your talent in support of my campaign. The political messages involved in your work have encouraged Americans to believe they can help change the status-quo.

Your images have a profound effect on people, whether seen in a gallery or on a stop sign. I am privileged to be a part of your artwork and proud to have your support. I wish you continued success and creativity.

Sincerely,

Barack Obama

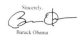

Obama'08

Obama for America • 233 N. Michigan Ave • Chicago, IL 60601 • BarackObama.com

Paid for by Obama for America

Thank-you letter from Barack Obama, 2008

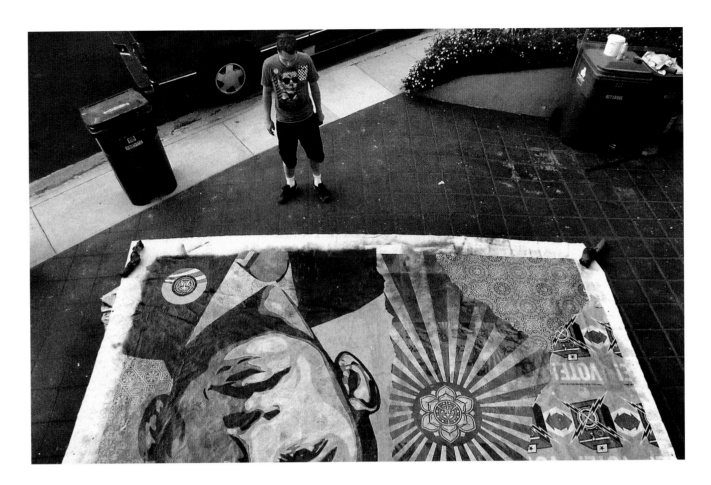

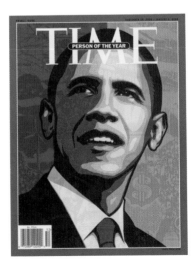

Shepard Fairey working on an installation in Los Angeles

Shepard Fairey
TIME Magazine Cover,
December 29, 2008

engage in democracy and use art as a tool of communication. Because they felt like they could really participate and have their voices heard by way of a candidate who shared their views, they were able to create in a constructive way. There was plenty of political art during the Bush years, but it was essentially an endless stream of anti–Bush criticism. I supported Obama because I saw him in direct opposition to Bush and the Bush policies that I'd criticized many times in my art.

A lot of people thought it was ironic that I made an image directly supporting something, since I've encouraged people for years through my Obey campaign to question the visuals they're confronted with and look at things more cautiously, but with the *Hope* portrait I was very sincerely making propaganda to support Obama. I still encourage people to question everything, but irony is frequently a way to be noncommittal with views. Once you've examined things, it's important to actually have a point of view that you're willing to stand behind. When I made the Obama portrait, I made my judgment that I could stand behind the guy and commit to his candidacy.

Somehow, everything I hoped for when I made the *Hope* portrait seemed to work. It's amazing what visuals can do. I've always thought they made the best tool for propagandist manipulation because they can project an essence onto someone that they might not really have, but I believed—and still believe—that Obama is genuinely the person I portrayed him to be, and the image helped reinforce those ideas for people who were not completely convinced, or at least made them curious enough to do their own research.

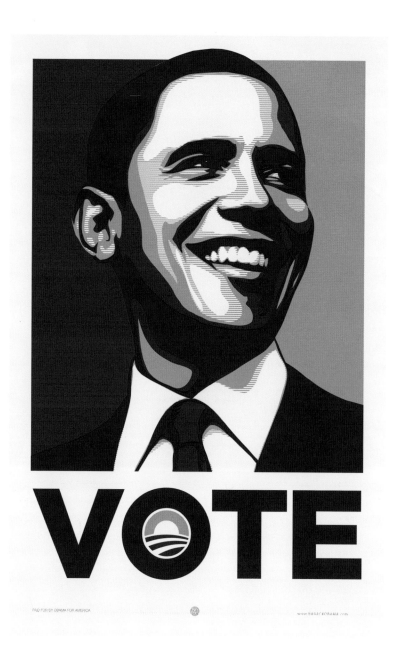

Shepard Fairey
Obama Vote, **2008**
Screen print poster
36 x 48"

Shepard Fairey
Obama Change, **2008**
Screen print poster
36 x 48"

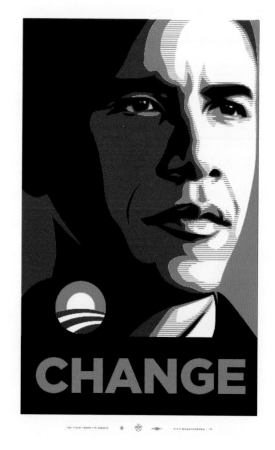

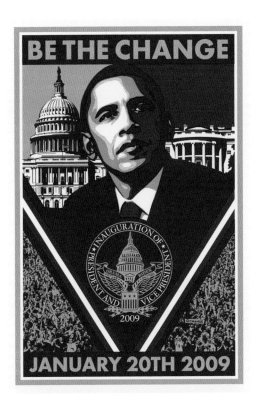

By the time Obama locked up the Democratic nomination, there was a definite domino effect of support within the art community, and it really began to feel like a movement. Artists didn't just prefer him to McCain; they thought, "This is a guy who we believe in." That was the really powerful part, because creative people are influential people, and the more they participate, the more they influence a younger crowd to vote and be more politically active. Eventually that can cause an entire shift in the political system. Right now, the way the political system works is that the people who stand to benefit the most from manipulating the system put the most effort into making sure the outcome is what they want. But if more people are involved, especially more young people, there can be more of a true representation of the wishes of the entire populace.

For me, art is how I communicate and amplify my ideas. There are a lot of other creative people who, rather than just making pictures, decided there was a lot at stake in this election and got involved. I hope that momentum continues, and that this campaign and the art around it will come to exemplify what I think was a significant turning point in history. I hope that people will recognize the value of art as a tool for communication and a way to make people consider things more deeply. I can't predict what's going to happen, but I'm really hoping for something like the Works Progress Administration—an arts program that can be used for the public good.

Art has been used as a tool for social activism, and of course to make beautiful, provocative visuals, for a long time. The works that were made around the Obama candidacy really brought that concept to a much wider audience. As a populist, I think the more people who decide to make art and try to say something with it, the better.

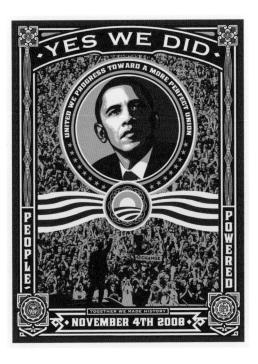

TOP LEFT
Shepard Fairey
Obama Inauguration, **2009**
Screen print poster
18 x 24"

BOTTOM LEFT
Shepard Fairey
Yes We Did, **2008**
Lithograph
24 x 36"

THE EVOLUTION OF
A REVOLUTION

JENNIFER GROSS, YOSI SERGANT, MEGAN ROLLINS
EVOLUTIONARY MEDIA GROUP

For us, it started before the poster. Maybe it was the October 2, 2002, anti–Iraq War speech. Or maybe it was reading *Dreams from My Father*. Or watching the keynote address at the 2004 Democratic National Convention.

It doesn't really matter when our inspiration to become a part of electing Barack Obama first began—we all wound up at the same place: *Manifest Hope*. There was a new brand of creativity that needed to be released. We knew we had America's youth, and we knew we had the artistic community. What we needed was a way to mobilize them both.

It took an artist's deeply rooted belief in accessibility; the public's insatiable appetite for visually demonstrating support; and a meticulously worked-out and strategic visibility effort to make Shepard Fairey's *Hope* poster the most recognizable image associated with the campaign to elect Barack Obama president of the United States.

That foundation is what speaks most profoundly to the success of the movement that followed. Revolutionary inventiveness was prevalent throughout Obama's campaign, and the *Hope* poster was no exception. Never in history has a guerrilla street artist who's been arrested fourteen (now fifteen) times connected so personally with the American public. The *Hope* image represented something different and the viral nature of the poster showed that the American people has both a hunger for personal expression and a willingness to overlook political correctness to show support for a candidate it believes in.

The effect of the *Hope* poster on the artistic community was a bit more unexpected. As Shepard Fairey's image took off, it was as though a fire had been ignited, motivating other artists to create and organize. In times of crisis, collective innovation often ensues, and the *Manifest Hope* project, cosponsored and co-organized by grassroots powerhouse MoveOn.org, was the greatest benefactor of the firestorm of creativity that occurred during this election. *Manifest Hope* offered remarkable exhibits, showcasing some of the finest modern contemporary artists, acclaimed painters and sculptors, activating grassroots and street artists, and displaying some of the most widely recognized pieces associated with the presidential campaign.

The *Manifest Hope* exhibits were set against the backdrop of the Democratic National Convention and the presidential inauguration, and as the exhibition galleries were being built, they began to take on the personalities of their respective cities. The spirit and energy of local volunteers brought a piece of the community with each nail that was hammered and brushstroke that was made, reinforcing the significance of grassroots organizing and lending to the exhibit and its surrounding events a flavor reminiscent of the campaign itself. To ensure inclusiveness, *Manifest Hope* invited the general public to participate in a nationwide call for entries, offering winners the chance to hang their works alongside those of famed artists. To reiterate the importance of accessibility, the doors were opened to the

Jennifer Gross, Yosi Sergant, Scot Lefavor, Megan Rollins, and Nik Harrington. Manifest Hope: DC, 2009

OPPOSITE
Tres Birds
HOPE, 2008
Andenken Gallery, Denver, Colorado
Bicycle spokes

13

public free of charge. To stimulate conversation, each exhibit asked patrons to harness their energy and direct it toward civic involvement and creative expression.

In facilitating conversation and activism through a collection of artistic works, *Manifest Hope* strove to give artists a prominent role in the 2008 election. It is a role artists have played throughout history: lending creative expression to new ideas in politics and culture. Combining innovation with art's greatest strength—its ability to make an impact without relying solely on language—*Manifest Hope* transcended boundaries through the universality of artistic expression. In an interview about Barack Obama, artist David Choe was quoted as saying, "I am going to support this guy in whatever way I can—which meant picking up a paintbrush."

That creative sentiment was shared by every person involved in the events. In both Denver and Washington DC, people passing by on the streets would stop to pick up a hammer or paintbrush and help with the build-out. In Denver, patrons and local artists were so inspired that created a mural on the wall across from the gallery, all searching for their own way to contribute. The energy was infectious, and everyone wanted to share in the experience.

One of the reasons the Obama campaign was so supportive of the galleries (shown through the involvement of staffers like Reggie Love, David Washington, and Michael Strautmanis) was because of the principles on which *Manifest Hope* was founded. Not wanting to stifle artistic creativity, but fearing deviation from a well-crafted platform of optimism, the campaign offered artist Ron English no direction other than to "stay positive." *Manifest Hope* followed suit. The effect resonated with all of us when Republican governor Arnold Schwarzenegger walked into the Washington DC gallery, instantly demonstrating how affirmative platforms can transcend party lines.

The comparisons of President Obama to President John F. Kennedy are not new, but the underlying themes of individual accountability and public service are being reawakened, especially for younger generations, and they are reminding all of us what it means to be American. President Obama's election signifies a shift in national perspective, as individuals take on the responsibility of being part of something bigger than themselves. Though the momentous historical significance of the campaign can never be relived, its revelations will linger forever: Hope is not audacious; youth can make a difference; and collective conscience isn't defined by party lines.

As the "Hope" campaign comes to an end and President Obama completes his first year, we know that our role as artists, citizens, and patriots is only just beginning.

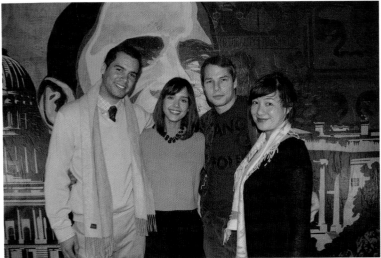

Cash Warren, Jessica Alba, Shepard Fairey, and
Amanda Fairey at Manifest Hope: DC, 2009

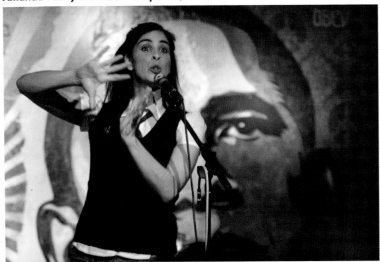

Sarah Silverman at Manifest Hope: Denver, 2008

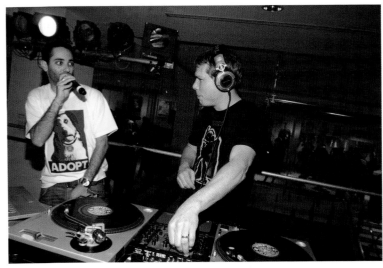

Josh "DJ Troublemaker" Kouzomis and Shepard Fairey
at Manifest Hope: DC, 2009

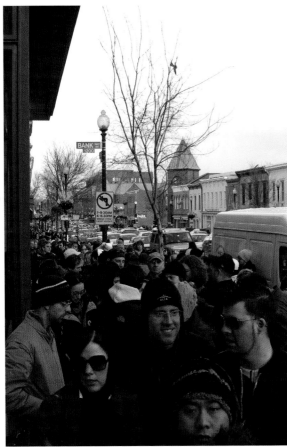

People waiting in a two-block line to get into the
Manifest Hope: DC gallery, 2009

Rosario Dawson and Eli Pariser
at Manifest Hope: DC, 2009

INFILTRATING THE SYSTEM

LAURA DAWN

CREATIVE DIRECTOR, MOVEON.ORG

I don't think artists can avoid being political. Artists are the proverbial canaries in the coalmine. When we stop singing, it's a sure sign of repressive times ahead.
—Theresa Bayer

I first met Shepard Fairey back in the early nineties, when I was touring in an all-girl punk band and he was wheat-pasting his Andre the Giant Has a Posse series of posters around the country. It was from Shepard's work that I saw my first glimpse of phenomenology, the idea that an object would manifest its own meaning—even an object as inherently meaningless as a nonsequitur about a professional wrestler—in action. I thought then that he was probably the Andy Warhol of my generation.

Although clearly influenced by earlier artists, from Duchamp to Burroughs, Warhol appropriated and recontextualized objects we wouldn't normally identify as art and forced us to reconsider what art is, and perhaps most importantly, whether it might be measured by its *influence*. So it seemed sound to me that Shepard's work was a next step on the shoulders of Warhol, with one vital difference: Shepard's early work, which raised so many of the same questions about how we ascribe meaning and value, was expanding and influencing *virally*—years before the Internet as we know it today even existed. People stood up to spread his imagery around the country without ever receiving an e-mail or a text, much less a Twitter asking them to do so.

I'm a musician, and since I've toured and traveled a lot, I've seen Andre the Giant stickers, posters, and stencils all over the world (most notably in the bathroom of a Communist-era jet while flying over Russia) every major city of the United States. And Shepard's fans were not only spreading his imagery around the globe, but they were creating and disseminating their own art as well.

Shepard's art had become a grassroots force with its own grassroots army, even if no one was calling it that back then. And the unique way that Andre the Giant Has a Posse was disseminated, popping up along city streets, on telephone booths, bus stops, and anything/everything in between, was a political demand in and of itself: the demand for public space to belong not just to highest advertising's bidder, but also to the public, for self-expression.

Look, I had no idea the Internet was about to explode. I had only the smallest inkling then of what it could all mean, a kind of thrill that something portentous was happening, that there was something bringing people of like minds together, people who were dissatisfied with the status quo and looking for a creative new way to engage. All I knew for sure was that I was one of them.

On September 18, 1998, Joan Blades and Wes Boyd sent out an e-mail to about eighty of their friends. It was a petition asking Congress to "censure President

Shepard Fairey, Laura Dawn, and Moby at Manifest Hope: Denver, 2008

Manifest Hope: Denver after party

17

Clinton and move on to pressing issues facing the nation." Joan and Wes had no prior political experience but shared a deep frustration with the partisan warfare in Washington and the ridiculous waste of our nation's focus at the time of the impeachment mess. Within days, their friends had forwarded the petition on to their friends, and hundreds of thousands of individuals had signed up. Wes and Joan, a couple of Silicon Valley entrepreneurs with two kids, had simply gotten fed up and sent out an e-mail. Now hundreds of thousands of responses crowded their inbox, begging for their voices to be heard.

Wes and Joan knew they were onto something. In the past, political organizing was a very slow and painful process. If you wanted to build a petition that you could present to your elected officials to let them know how the public felt about an issue, then you actually had to go door-to-door, or stand outside of a supermarket and physically collect the names. If you wanted to fund-raise for a candidate or an issue, you had to physically go ask for the money, or do so via direct mail, which only yielded about ten cents on the dollar.

Wes and Joan knew, after two hundred thousand people had signed their little petition, that the Internet had *just changed everything*—the Internet could serve as the conduit for the possibility of real democracy. And thus was born MoveOn.org, which in time became the largest grassroots citizens' advocacy group in the history of the United States.

Historically, in American politics, only large corporations or heavily moneyed interests could lobby our elected officials. And that's an inherently bad and unfair state of things; we elect these representatives. Our tax dollars pay their salaries, and they are supposed to work for and in our best interests. Yet the only voices in their ears were those of deep-pocketed corporations, who don't always put the needs of everyday people before their profit margins.

Then MoveOn came along and created a system where regular, everyday Americans could chip in twenty-five dollars each and get an important advertisement on the air, where millions of us could band together to raise $80 million for a candidate, and where we could build a petition of a million citizens with one e-mail. Finally, the inequality of the power structure was turned on its head, and the people were back in the process.

When I joined MoveOn.org as a member in 2003, and then as a staff member in 2004, I got that feeling again: Something big was happening. That sense of possibility, that there was finally a way for like-minded people to reach each other, to band together to stop the insanity that was leading the country into war, corporate oligarchy, and both moral and literal bankruptcy. At the time, just pushing back against the Bush administration and revealing the depth of its mismanagement seemed a big enough hill to climb. The idea that we could help grow a movement that would not only end the Bush era but elect a real progressive into the White House seemed too much to even dream about.

ABOVE AND OPPOSITE
Volunteers and artists working on the art installation at Manifest Hope: DC, 2009

At MoveOn, we have always sought to work hand in hand with artists, celebrating the creativity and talent of our membership and also working with established artists. I've seen some amazing things come out of these collaborations. I've seen

established filmmakers help elevate the voices of returning vets who wanted to speak out against the war; I've seen actors and writers and musicians collaborating with millions of grassroots activists for change; and I've seen the smallest sparks of good ideas grow into campaigns that pricked (or at least irked the hell out of) the very conscience of a sitting president.

Artists have long been major instigators of social and political change. Especially during oppressive times, such as the Bush administration–era, when political questioning was actively painted as a traitorous action, artists are frequently on the front line, daring to think outside the boundaries of "permissible" thought, daring to say first what no one else will say—or more dangerously, what so many others think but are afraid to say. And artists don't just spout platitudes on TV, like today's talking head commentators—they deliver messages through media that stick. Do you remember the first time you saw Oliver Stone's *Platoon*? Or Picasso's *Guernica*? Or the moment you finished reading Norman Mailer's *The Naked and the Dead*?

Art isn't just a reflection of current politics or cultural mores. Novels, visual art, stories, films, televisions shows, and Internet shorts: This is the well of social capital that shapes our opinions. Art is the place where our beliefs are forged and from which consequent actions ultimately spring.

Which means simply that art is important and that artists *can be powerful in a political context.*

Certain elements in the Bush administration and the Republican Party liked to talk a whole lot about "culture wars." They tried to convince Americans that "elitism" is cultural. They tried to convince Americans that the real problem in the United States wasn't the war, or poverty; it wasn't that the richest 1 percent own 38 percent of all the wealth, or that 50 million of us live every day with no health insurance. No, the real problem in the United States, according to the right wing, was that painter Chris Ofili asked us to question racial and sexual stereotypes by giving us a challenging depiction of the Virgin Mary. Or that Sean Penn visited Iraq before we bombed it, while questioning the motives behind our imminent attack. Or that gay citizens wanted to have the same right to marry their life partners as straight ones.

Elitism is not cultural. It is always socioeconomic. It is always about money—about access to health care and access to education. When you give the public the tools to participate in their own governance, that is the real stirring of life, liberty, and the pursuit of happiness—the stirring of a real democracy, or as MoveOn–ers like to say, "Democracy in Action." When you deny us those tools, and seek to keep us distracted with lies, half–truths, and mock scandals, not to mention fear and intimidation—well, that is something that is altogether *not* democracy.

Back before the Internet boom, Shepard Fairey's art created a conversation in public spaces that required the viewer's participation. And I'd say that's not too far off from what MoveOn accomplished ten years and one disastrous presidency later: a way for the public to meaningfully engage with their elected representatives. Finally, a real two–way street.

So when Shepard, along with thousands of other artists, joined forces with MoveOn.org's now 5 million members in the effort to elect Barack Obama, it made a kind of immediate sense. Innovative portraits and graphic design from artists around the country became a powerful symbol of the country's desire for change, and engaging artists—from the community level to the international level—became a central strategy to inspire passion and to win the presidential race. Artists and activists, working side-by-side, helped illuminate the perception of not only a man, but a movement. Together, we *can* create monumental change.

When Shepard's now iconic portrait of Barack Obama was inducted into the Smithsonian in January 2009, I stood slack-jawed among a more diverse crowd than Washington, DC may have ever seen that early in the morning. Slick senators and their aids stood alongside artists with multihued hair and skateboarders with facial piercings—all to watch one renegade-artist-turned-grassroots-hero's portrait of what so many thought an impossible-to-win candidate. Just a few days before that improbable candidate's inauguration as president of the United States of America.

I asked Shepard afterward, "Could you ever have imagined, back in the mid nineties, that one day we'd all be standing here?" And he said, "No. But somehow we infiltrated the system."

I think he's right. Somehow, through the emergence of the Internet, from the mixture of new ways to communicate and create, people banded together and put a stop to a way of government that was no longer for the people or reflective of the greatness of this country. And now we face, together, the biggest hope of all: the chance to rebuild.

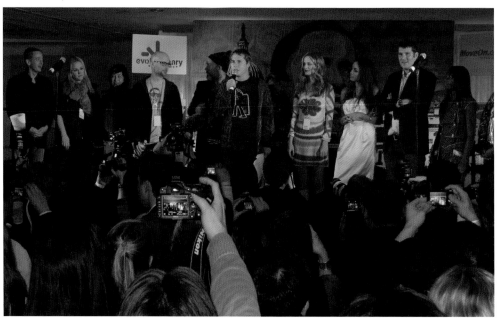

Host Committee for Manifest Hope: DC, including David Rolf, president of SEIU Local 775 in Washington state, Amanda Fairey, Moby, Michael Stipe, Shepard Fairey, Heather Graham, Rosario Dawson, Eli Pariser, and Santigold, 2009

Governor Arnold Schwarzenegger at Manifest Hope: DC, 2009

Tim Robbins and Josh Lucas at Manifest Hope: DC, 2009

Zooey Deschanel singing at the Manifest Hope: Denver after party, 2008

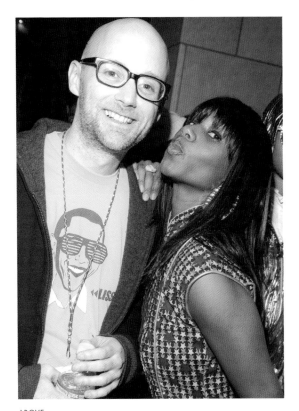

ABOVE
Moby and Santigold at Manifest Hope: DC, 2009

LEFT
David Washington, Ilyse Hogue of MoveOn.org, and Michael Strautmanis, Chief of Staff to the Assistant to the President for Intergovernmental Relations and Public Liasion, at Manifest Hope: DC, 2009

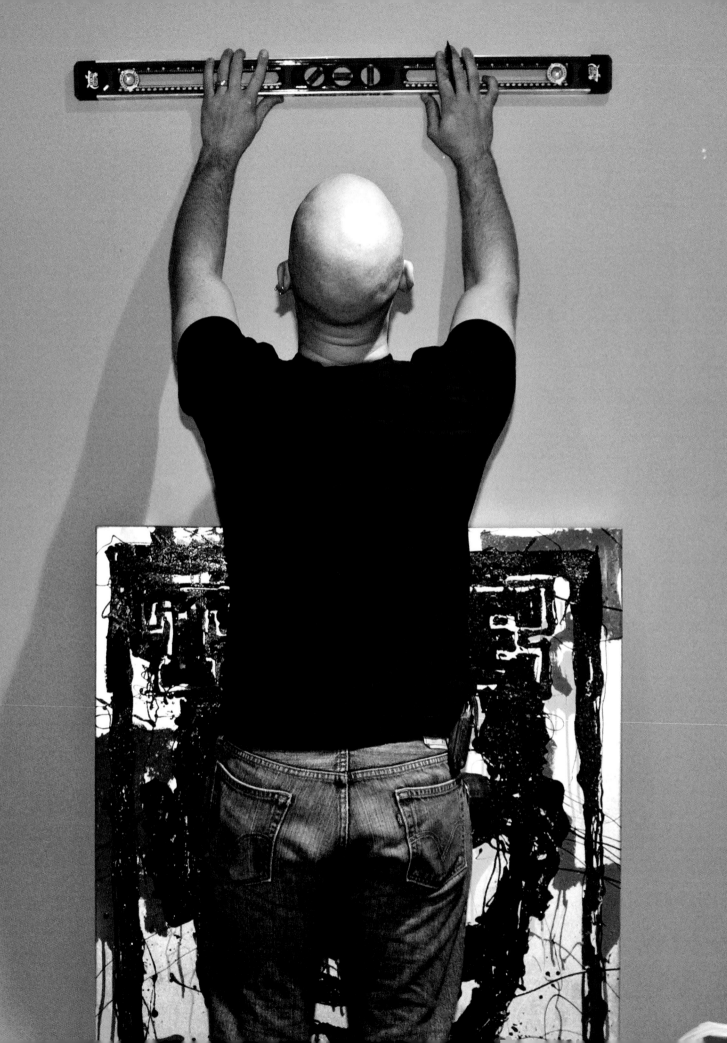

UNITED BY INSPIRATION

MICHELLE MILLER
MANAGER OF POPULAR MEDIA ORGANIZING, SEIU

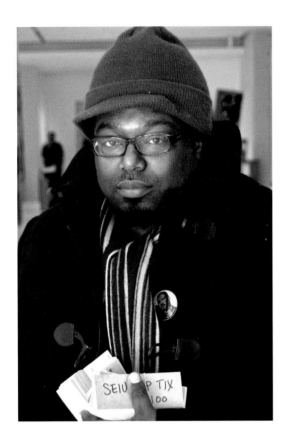

ABOVE
**Stephen Chavers from the
SEIU at the Manifest Hope
gallery in DC, 2009**

OPPOSITE
**Thomas W. Powell install-
ing his art at Manifest
Hope: DC, 2009**

*The 2 million–member Service Employees International Union is the fastest-
growing union in North America, and its membership is among the most diverse
in the labor movement. Focused on uniting workers in three sectors, SEIU is the
largest health care union, including hospitals, nursing homes, and home care; the
largest property services union, including building cleaning and security; and the
second largest public employee union.*

Working people have a long history of integrating art and culture into
our movement for social change. Throughout the past century, every
great advance for working people was the result of a combination of
grassroots organizing, workers talking to workers, and a variety of figures from
our communities—politicians, representatives from religious groups, writers,
musicians, and artists—working together in our struggle for justice. At the root
of our work is the fundamental desire for all people to have a say in their desti-
nies. We build unions because when we join together and make our voices heard,
we create workplaces and communities that reflect our hopes and dreams. Many
artists create work that is deeply rooted in that same need for self-expression.
For that reason, SEIU established an arts and cultural program more than ten
years ago dedicated to the power of the arts to magnify the stories and voices of
our members in compelling and innovative ways. SEIU members are not simply
defined by our job titles. We are members of communities and religious organiza-
tions, political office holders, and artists. We have built programs over the years
to maximize the talents of SEIU members as painters, photographers, videogra-
phers, singers, storytellers, and crafters, and established long-standing relation-
ships with artists who express the stories of working people in a multitude of
imaginative ways to audiences we couldn't otherwise reach. It was in this tradi-
tion that we joined with Obey Giant, Evolutionary Media Group, and MoveOn.org
for the *Manifest Hope* exhibit in Denver and Washington DC.

The *Manifest Hope* exhibits were opportunities to honor and value the critical role
artists played in the 2008 Obama campaign. These artists took concepts and is-
sues that were central to the campaign—hope, change, civic participation, health
care reform, the green economy, and more—and translated them into compelling
visual statements. After eight years of politics consumed with despair and fear,
the Obama campaign was challenged to communicate an alternative vision of
what was possible. In conjunction with the time-honored work of door-to-door
canvasing, phone banking, and fund-raising, these visual works mobilized and
energized everyday people across the country who were ready for change. This
did not happen because campaign leaders went out and commissioned artists to
create these images or told them what the images should contain. Instead, in the
same way the campaign empowered people to phone their neighbors from their
homes or develop their own approaches to fund-raising, it created space for art-
ists to communicate Obama's message in ways that reflected their own artistic
styles, personal histories, and communities. The result was a collection of art

fueled by the personal passions and visions of the artists, but connected by a singular overall goal of changing this country. There was a proliferation of pins we could hand out to our friends, posters we wanted to keep on our walls after Election Day, and even pumpkins glowing on stoops across the country, all a result of creative ingenuity and political passion. These images mattered. They connected to everyday voters in ways that traditional campaign literature couldn't. They touched our hearts or made us laugh or helped us to see behind politics, in a more human way.

Today we have an energized and diverse electorate, committed to seeing through the change that we worked so hard to bring to Washington in 2008. For SEIU members in particular, this election was about some key issues we've been fighting for for years—real health care reform and a fundamental change in the process everyday workers face when they try to form a union. When SEIU members across the country gathered on Saturday mornings to knock on doors in their communities or packed suitcases for long stays in battleground states to help with the campaign, they were determined to see real, tangible change in the new administration. One such member, Samara Knight, is a nursing-home worker in Cleveland, Ohio. Her hours at the nursing home had been cut, along with the health care that she needed to care for her very ill son. One night, when she was rubbing her son's back to ease his pain, she heard Barack Obama talk about his own mother's battle with cancer and what it meant to spend half her final days fighting with insurance companies. For the first time, Samara saw a political leader talking in a personal way about the same struggles she was facing. From that moment on, she committed herself to the Obama campaign, spending every available hour convincing her friends and neighbors to get out and vote. Samara was driving home when Obama's victory was announced. The first call she got was from her son, who said, "Now we can go to the doctor!" Samara remains committed to seeing everyone have access to health care. SEIU members across the country—health care workers, nursing-home and home-care aids, and mental health/developmental disability caregivers—work daily in a system that is failing their patients, residents, and clients. The election of Barack Obama is an unprecedented opportunity to reform our health care system, to provide quality, affordable health care to everyone in America, regardless of their personal wealth or ability to pay. Some of the most inspiring and compelling art in the *Manifest Hope* shows was centered on that fundamental need for quality health care. Artists are impacted significantly by this crisis and have their own personal stories to tell about what it means to skip a doctor's appointment or let an illness go until it's too late.

Reforming our health care system is one part of addressing the ongoing economic distress we are facing in all our communities. The root of the problem is a system that ignores the voices and needs of everyday citizens and rewards greed and corruption. Right now, we have an opportunity to pass legislation that will make it easier for workers to form unions and have their voices heard on the job and in their communities. When workers form unions, we can hold corporate leaders accountable for their actions and take an active role in decisions that impact us all. We have seen that, for millions of Americans, the old way of doing business, the Wall Street approach, is not working. We are in a crucial moment when we can all work together—political leaders, workers, grassroots organizers, and artists—to envision a bold new plan. Artists have a fundamental role to play in creating this

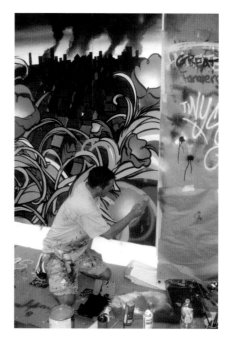

Sam Flores installing his work for Manifest Hope: Denver, 2008

Michael Murphy installing his work for Manifest Hope: DC, 2009

vision. At their best, artists see possibility and wonder where others see dead ends. The Obama administration knows that artists have much to contribute to our future and continues to engage cultural organizers in work to stimulate and revitalize cities, towns, and neighborhoods all across the country. As the labor movement pushes to create more just and fair workplaces, where all our contributions are valued and our voices are heard, we hope to continue joining with artists to find innovative and compelling ways to express our hopes and dreams.

When we look at the year ahead, there are more amazing opportunities to keep artists engaged in electoral politics. The 2010 election holds great promise for our communities. Artists and workers put in millions of hours to elect Barack Obama, and we know that the best way to preserve and grow what we worked so hard for is to put people who support our agenda in office. We need to elect congressional representatives, governors, and state and local officer holders who share our vision.

The collection of art presented in this book is a demonstration of the incredible creative potential and political savvy of artists across the country. The 2 million members of SEIU—janitors, security officers, home-care, hospital, nursing-home, and public workers—are all proud to have been a part of curating and collecting these incredible pieces of art. We consider artists to be our allies and partners in moving a progressive agenda for the country, one that honors our work, values our voices, and allows us all the opportunity to reach our greatest potential.

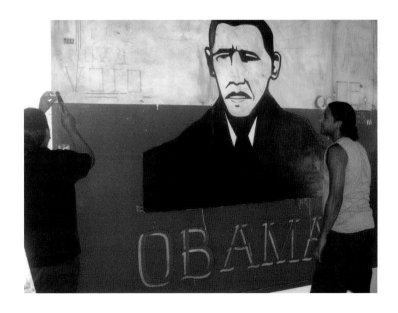

The Date Farmers artist collective installing its work for Manifest Hope: Denver, 2008

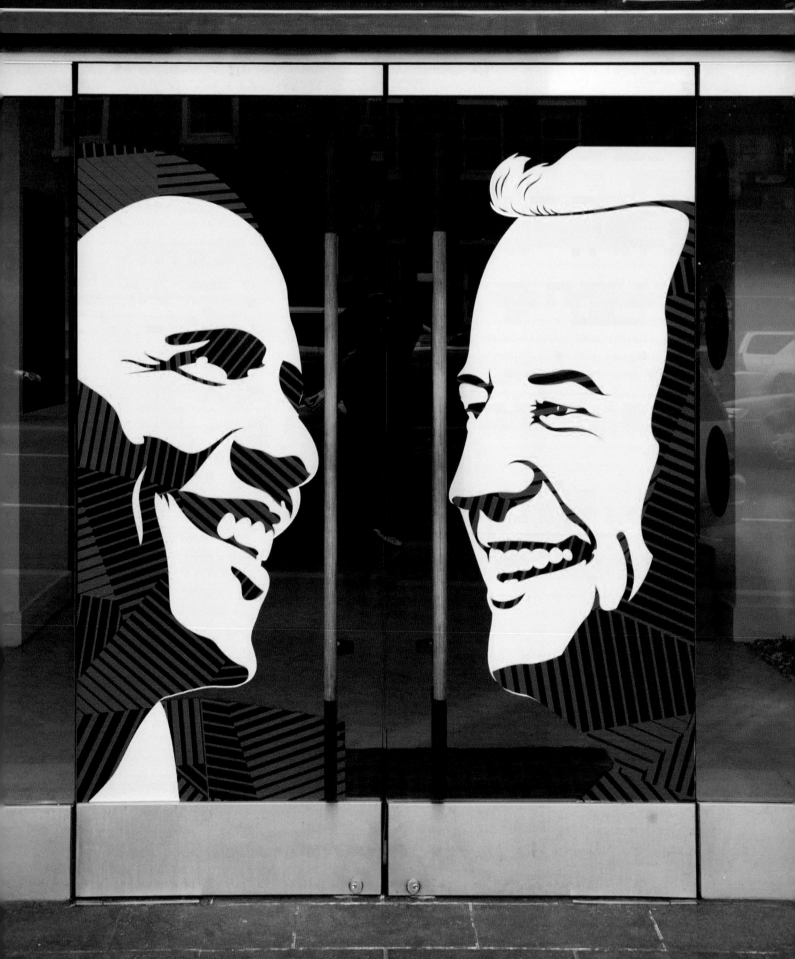

HIGH TIDE ON
THE CAPITAL'S SHORES

MARTIN IRVINE
OWNER AND DIRECTOR, IRVINE CONTEMPORARY

Manifest Hope: DC was a truly unprecedented event that engaged people from across the entire nation to celebrate the role that art and artists played in the movement that helped bring Barack Obama to the White House. I was thrilled to be invited by Shepard Fairey and the event's producer, Evolutionary Media Group in L.A., to be the show manager for ManifestHope:DC, and I'm delighted that the significance of the event lives on in this book.

America has never witnessed a time when the message of a new president generated such new wave of visual expression, and *Manifest Hope*: DC captured this exciting moment. The exhibition presented over 150 artists from around the country, including fifteen from the Washington area, and many more artists traveled to Washington to be present at the show and to help with the installation. *Manifest Hope*: DC represents an extraordinary populist engagement of artists, musicians, and creative people of every category who became energized by the possibility of new hope for America that Barack Obama had so convincingly communicated in months leading up to the election.

Deb Everhart and Martin Irvine at the Manifest Hope: DC after party, 2008

The great response to *Manifest Hope*: DC by artists and visitors also showcased Washington as a cultural center reaching its own turning point. Over twenty thousand people visited the show over four days, making *Manifest Hope*: DC one of the most sought–after venues during the Inauguration week. But the show was more than an Inauguration event: It captured new visual languages for political and socially aware themes not seen before in American art.

In addition to the great support by Evolutionary Media Group, the show wouldn't have been possible without the help of many DC volunteers and artists who worked with us over many long days to prepare the show and welcome visitors. I want to especially thank my great staff at Irvine, Lauren Gentile, Thomas Powell, and Deborah Everhart, for their dedicated professional management of the show. Many thanks to Robin Bell for photography, and to Richard Gould and Michael Pollack for their help with the installation. To everyone who contributed to *Manifest Hope*: DC, many thanks; I'm honored to have had this opportunity to work with you.

OPPOSITE
The doors to Manifest Hope: DC, vinyls designed by Studio Number One, 2009

HOPE MANIFESTED

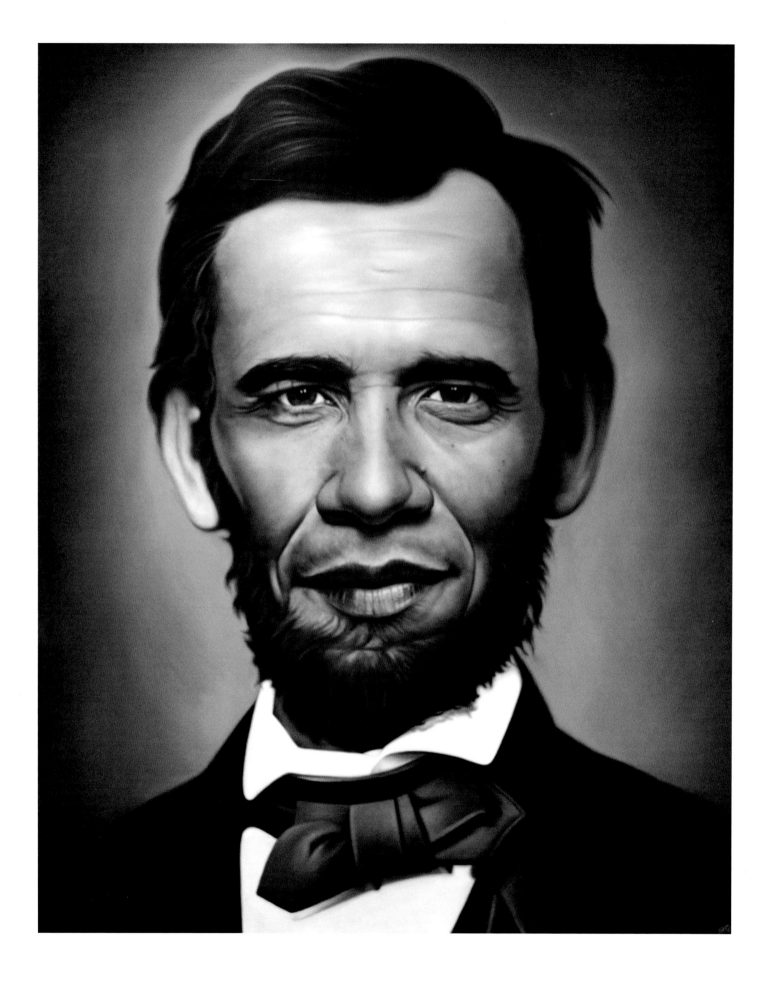

Ron English installing Abraham Obama *for*
Manifest Hope: Denver, 2008

Ron English
Blue Abraham Obama, 2008
Oil on canvas

RON ENGLISH

"The whole atmosphere of Denver was in keeping with the themes of Hope and Change. The community of artists, writers, actors, comedians, musicians, and organizers that came together to begin the honest work of rebuilding our country on a foundation of progress, hope, and humility . . . it was all very inspiring and a lot of fun.

Everyone lent their own particular talents to the challenge at hand in the same way that a community comes together to build a barn. Maybe you're not a carpenter, but you help make lunch, or haul lumber. If you're Will.I.Am, you make a hit song in support of the campaign. If you're Shepard Fairey, you create an indelible image of Obama. If you're Sarah Silverman, you deliver a punch line with a purpose.

Obama has also allowed a plethora of artists to interpret and disseminate his image, and those of us who had any involvement with the campaign were only nudged with one mandate—please stay positive. The Obama art phenomenon was truly a self–initiated, populist movement. It's a culmination of a lot of events that happened at the same time, including the global rise and embrace of street art, with the most important street artists to the least known seizing their own power."

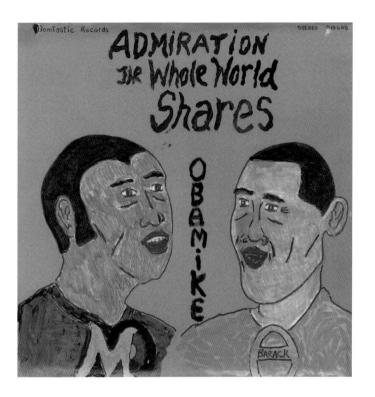

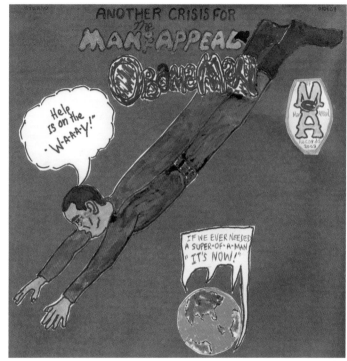

Mingering Mike
Admiration the World Shares, **2009**
Posterboard, tester paint, and
various markers and pens
12 x 12"

RIGHT
Mingering Mike
(Another Crisis for the Man of Appeal)
Obamaman, **2009**
Posterboard, tester paint, and various
markers and pens
12 x 12"

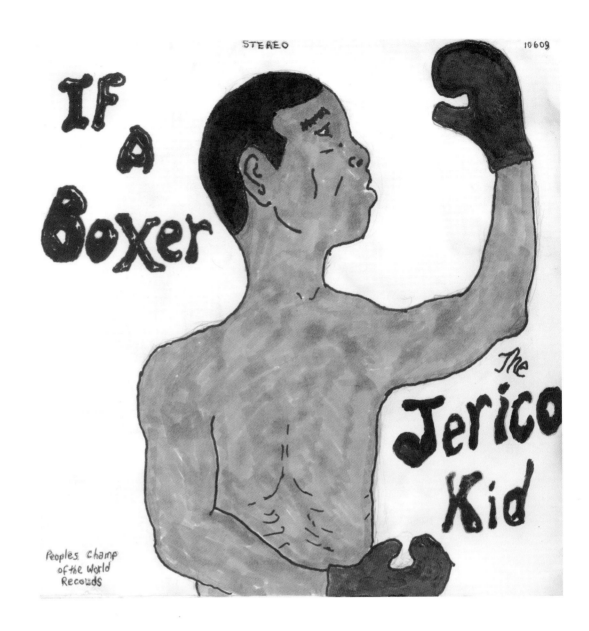

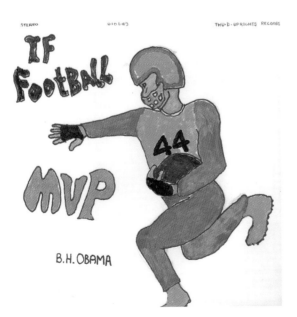

ABOVE

Mingering Mike

If a Boxer, the Jerico Kid, **2009**

Posterboard, tester paint, and
various markers and pens
12 x 12"

LEFT

Mingering Mike

If Football MVP, **2009**

Posterboard, tester paint, and
various markers and pens
12 x 12"

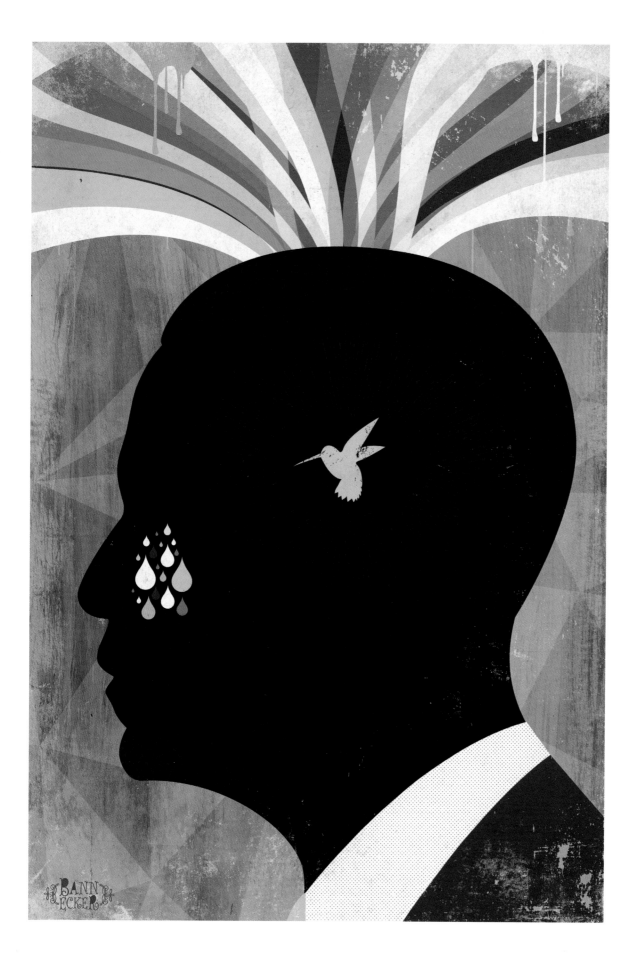

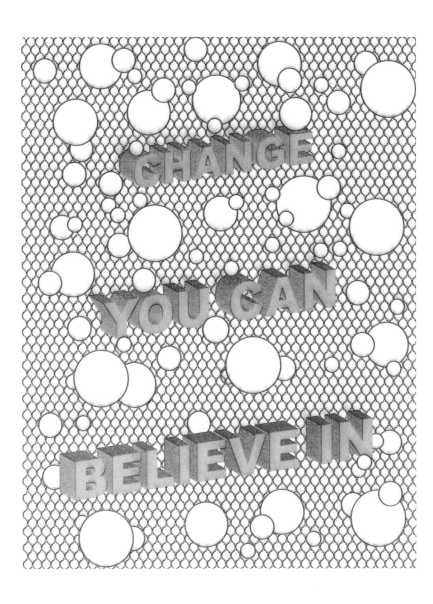

ABOVE
Guillermo Bert
Change You Can Believe in, **2008**
Laser cut on museum board
12 x 16"

LEFT
Rafael Lopez
Fuerza en La Diversidad, **2003**
Acrylic on canvas
18 x 18"

OPPOSITE
Andrew Bannecker
Tears of Hope, **2008**
Chromogenic print
mounted on panel
24 x 36"

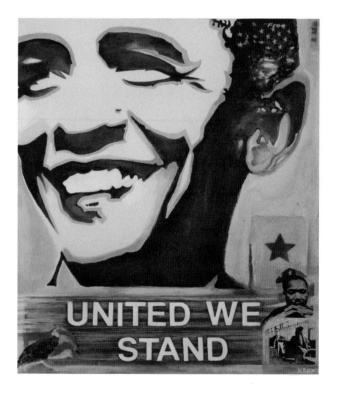

ABOVE
Dan "Stenzskull" Woehrle
Revolution Resolution, 2008
Multi layer stencil on stained
panel with distressed poster
and wood carving
24 x 30"

RIGHT
Katherine Kendall
United We Stand, 2008
Mixed media, paint on canvas
30 x 36"

OPPOSITE
Tatyana Fazlalizadeh
Kenyan–American, 2009
Oil on canvas
24 x 30"

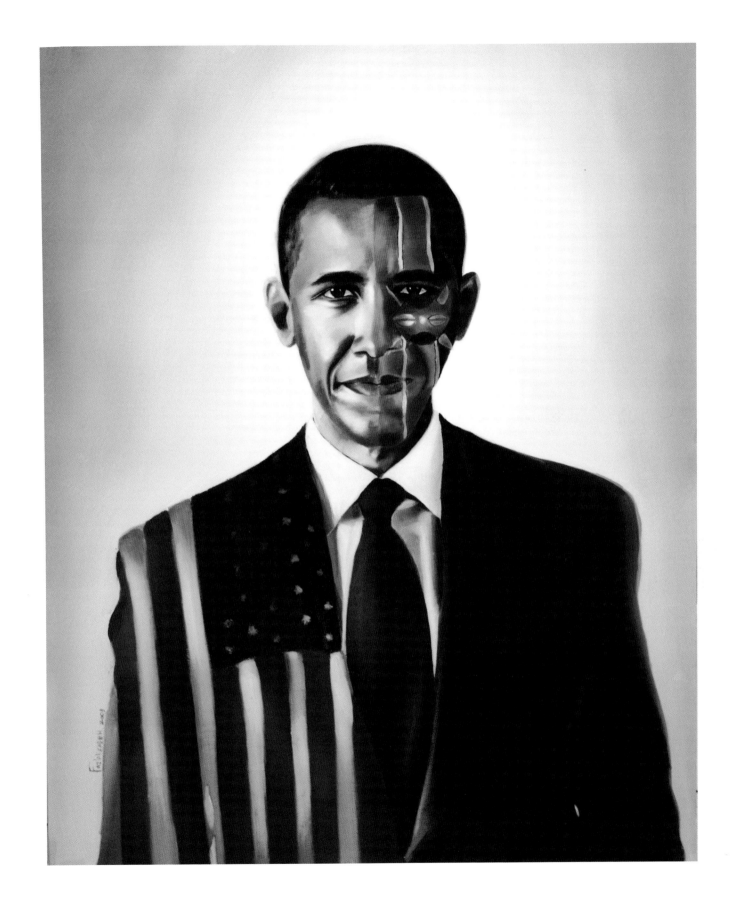

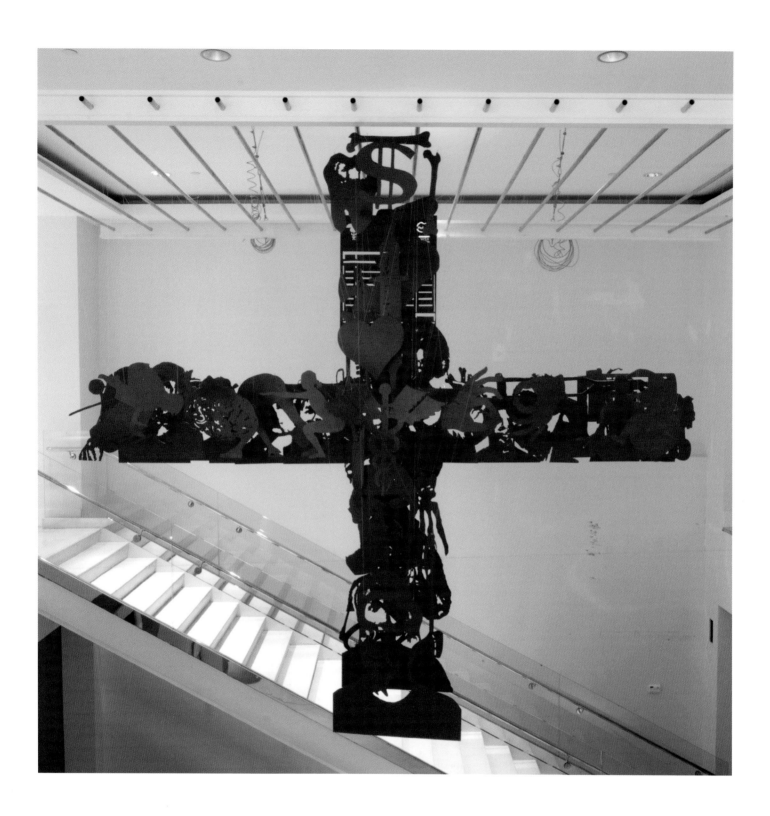

Michael Murphy
Red Cross, **2009**
Oak, steel, monofilament
144 x 192 x 108"

Detail of *Red Cross*

MICHAEL MURPHY

"On the occasion of her suicide in 1962, Andy Warhol created this image of Marilyn Monroe. It has since become one of the most widely circulated and pervasive images of our time. So why did Warhol create images of Monroe? Because of her fame and importance to the era. She was an iconic figure to nearly all women and wanted by most men. Another of Warhol's most celebrated works is the screen print of the Campbell's soup can, yet another icon in American Culture. Almost everyone has a can of Campbell's soup in their home. It's already a pervasive image. So by creating images of Monroe and the soup cans, Warhol made those images his and forced the public to associate these images with both him and his work. He used these icons of popular culture as a vehicle to deliver his art to the public.

So I asked myself, 'What individual is the entire world going to be wanting images of?' Barack Obama. I googled the word Obama and your typical campaign images of the candidate came up as did one artwork. It was a sculpture entitled *blessing* by David Cordero, a student at the School of the Art Institute of Chicago. It was a derogatory depiction of Obama as a savior or messiah, poking fun at the way so many people were so enamored with the candidate. I then googled 'Obama Art' and dozens of images of the sculpture came up. There was no other Obama art. I decided then that I would try to make the most interesting image of Obama that could be found on the internet. The Obama art market was an open field."

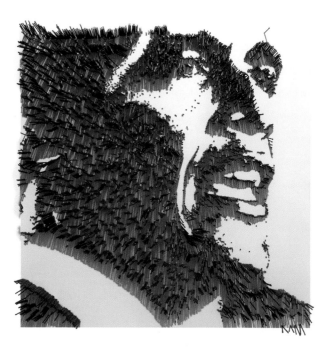

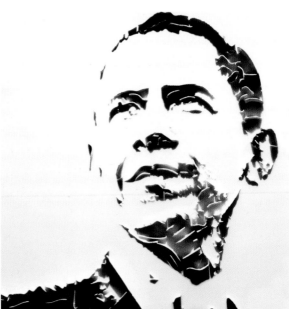

TOP LEFT
Michael Murphy
Obama Nail Portrait, **2007**
Light, shadows, 6,400 2"
nails, oak plate
24 x 24"

BOTTOM LEFT
Michael Murphy
Forward, **2008**
Light, shadows,
high performance urethane
24 x 24"

BELOW
Michael Murphy
Ascension, **2009**
Tension wire, pine base
24 x 34 x 144"

OPPOSITE
Michael Murphy
Tension, **2008**
One thousand feet of high
tension wire, black enamel, oak
24 x 34 x 144"

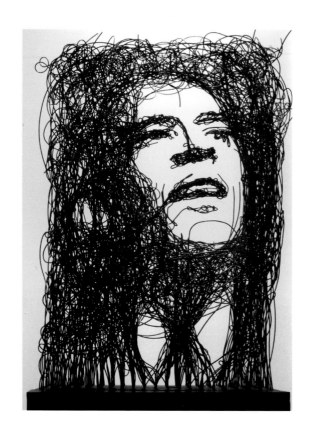

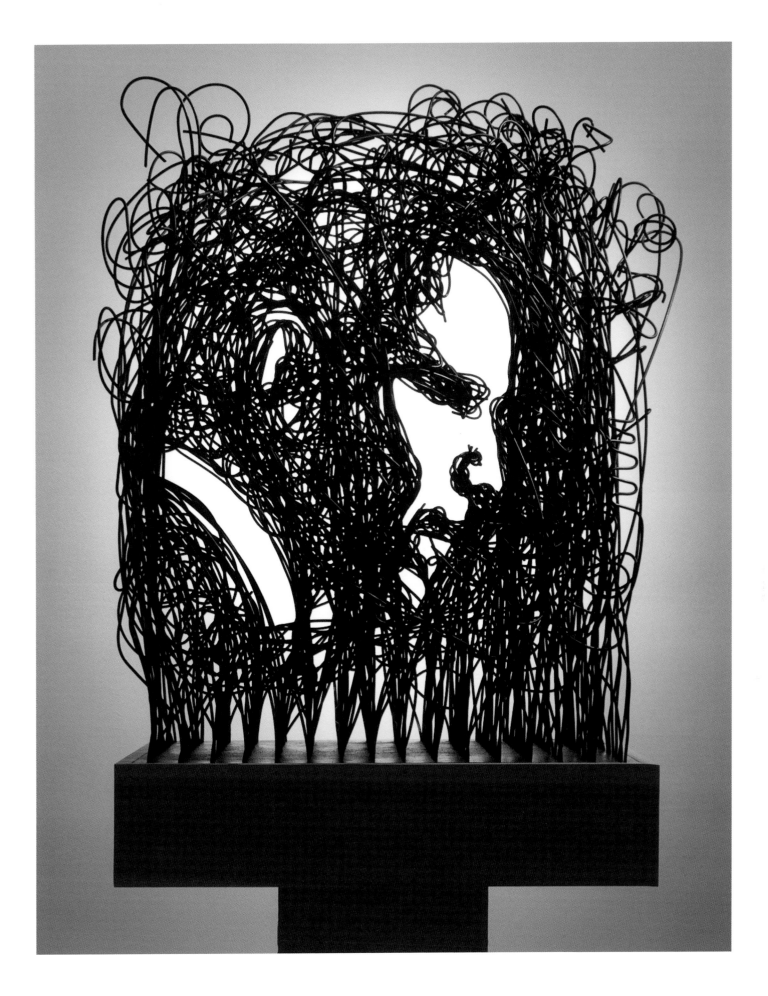

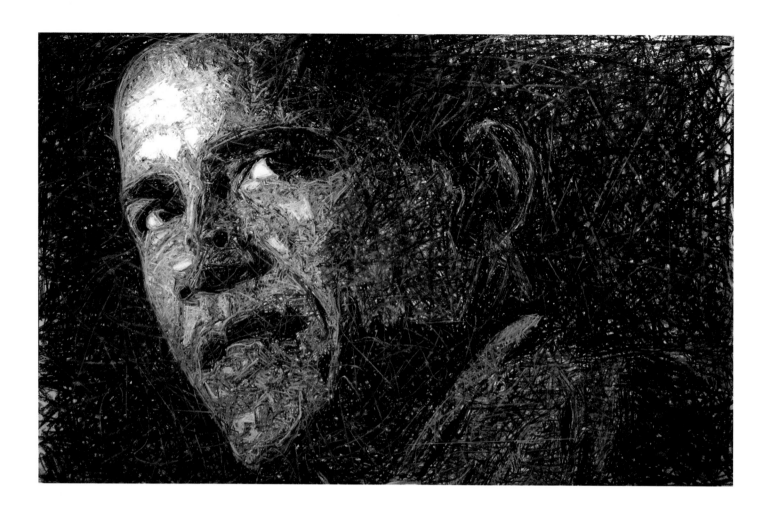

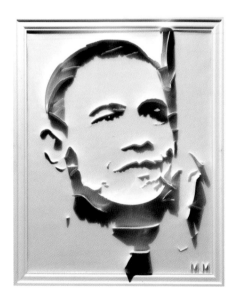
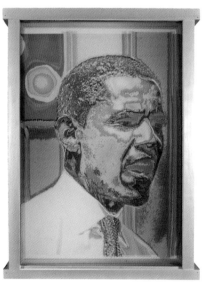

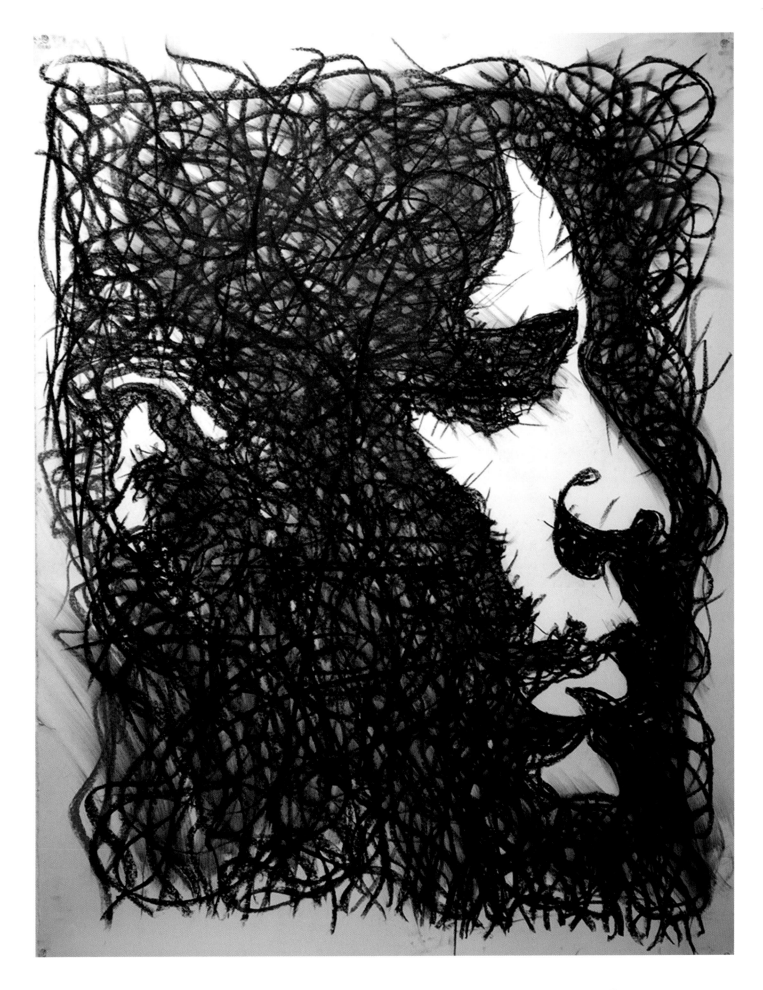

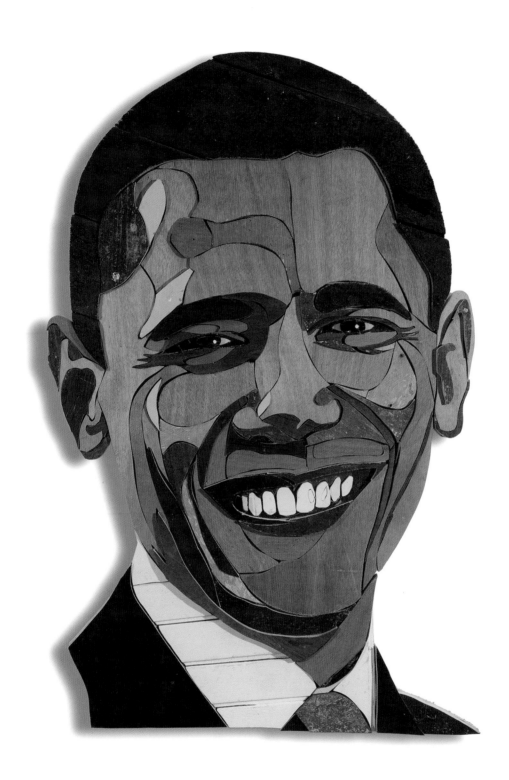

Diederick Kraaijeveld
Barack Obama Portrait, **2008**
Vintage wood found on the
Mombasa beach in Kenya
30 x 47"

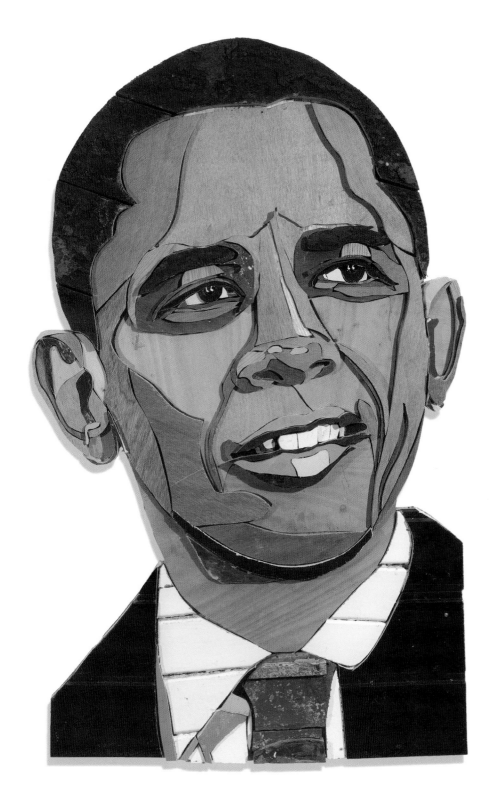

Diederick Kraaijeveld
Mr. President, **2009**
Originally colored
salvaged/reclaimed wood and nails
31½ x 48"

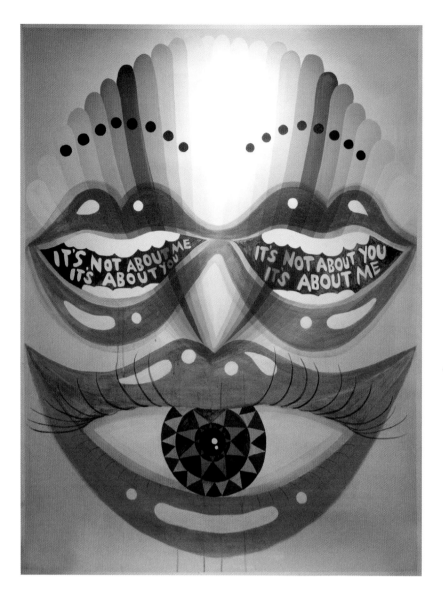

MAYA HAYUK

"The idea behind this (*Manifest Hope*) piece was to invite people to be inside of this shouting, active mouth so they could feel like they are a part of the solution, rather than onlookers placing all their faith in a messiah-like politician."

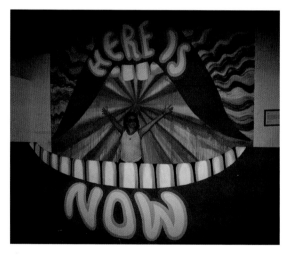

ABOVE
Maya Hayuk
Visualize Our Shared Responsibility, **2009**
Acrylic and latex on paper
38 x 50"

RIGHT
Maya Hayuk
Here Is Now, **2008**
Acrylic and aerosol on Masonite and plywood
120 x 120"

OPPOSITE
Maya Hayuk
The Future's So Bright I've Got to Get Gay, **2008**
Acrylic on canvas
50 x 72"

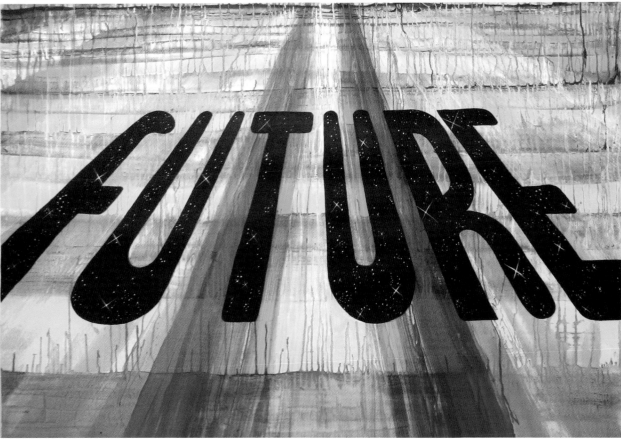

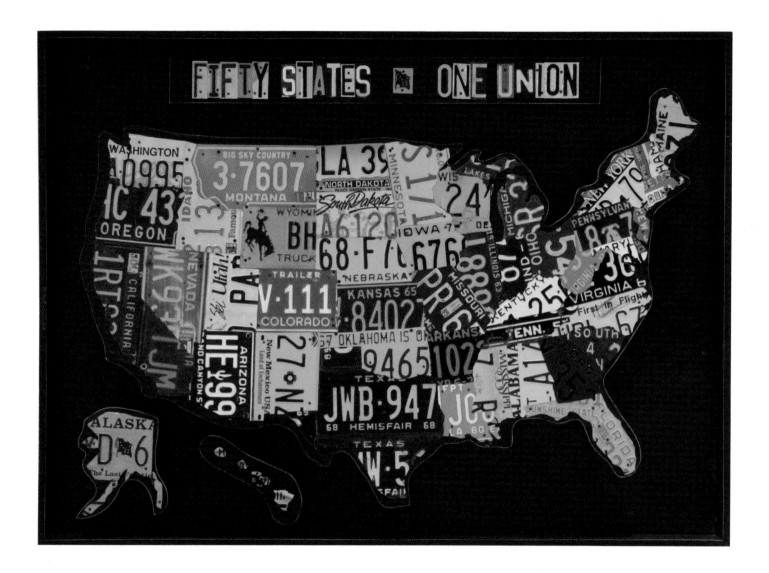

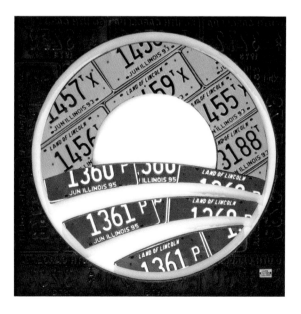

Aaron Foster
Fifty States – One Union, **2008**
Vintage license plates
63 x 45"

Aaron Foster
Obama Logo, **2009**
Recycled license plates and pine
36 x 36"

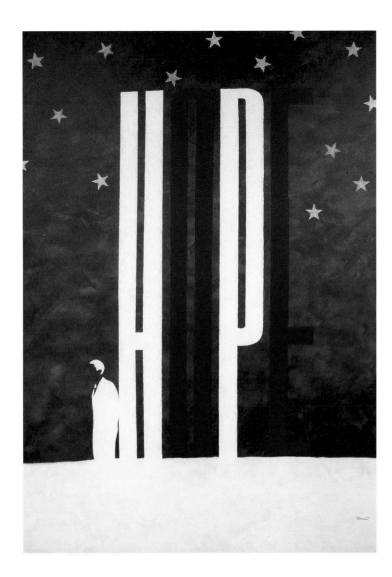

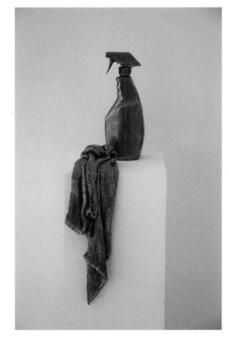

ABOVE
Frederic Terral
Hope Behind Everyman, **2008**
Acrylic on canvas
72 x 96"

ABOVE RIGHT
Christopher LaVoie
Workers Rights;
Bottle and Rag, **2008**
Bronze
20 x 20 x 20"

RIGHT
Guillermo Bert
Change, **2008**
Mixed media with laser
cutter and gesso
16 x 12"

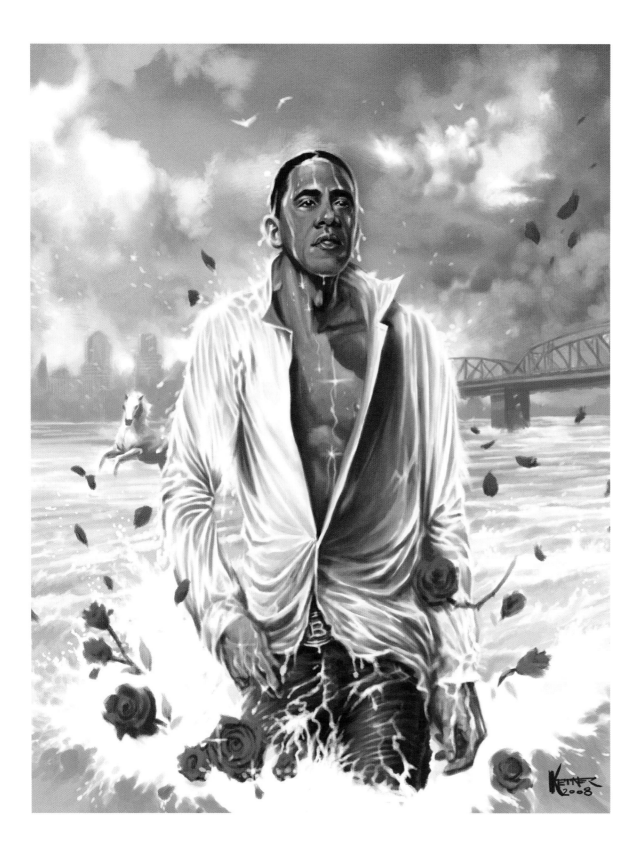

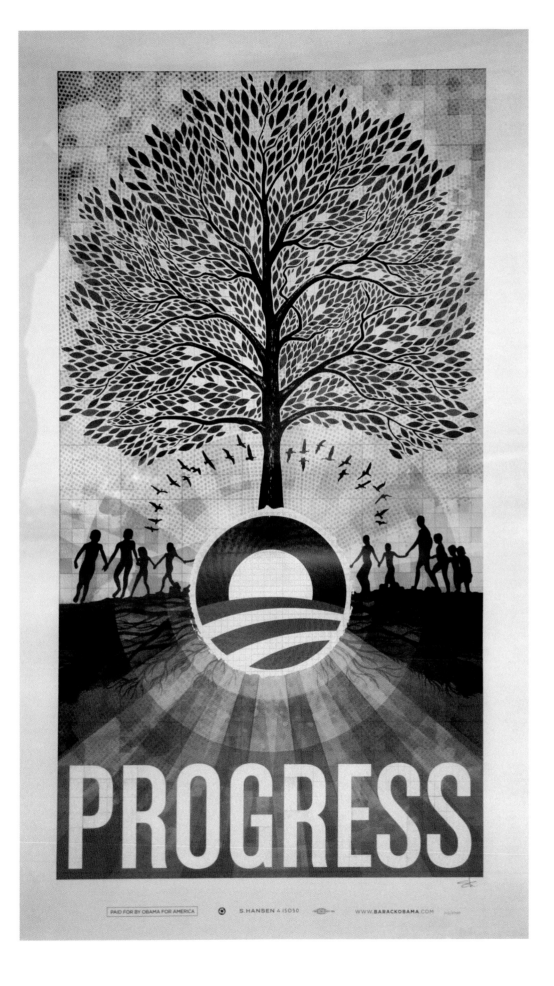

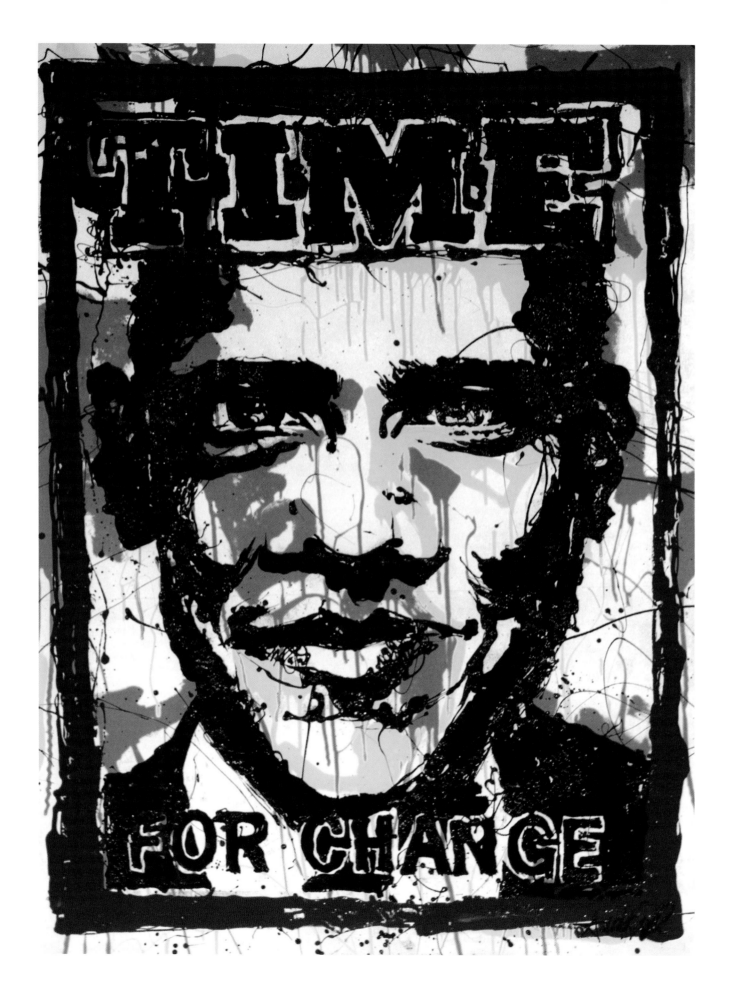

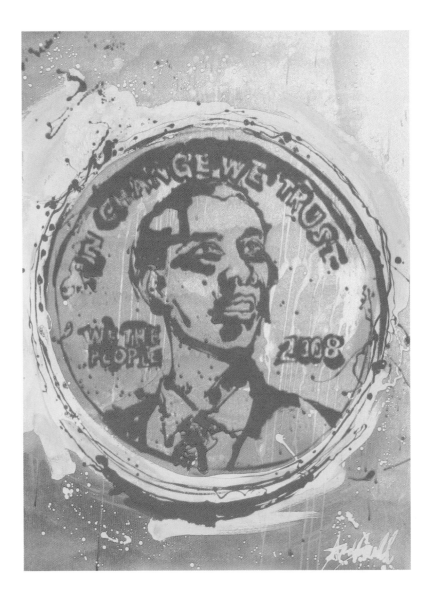

ANDY HOWELL

"The overarching ideals of Unity and Patriotism stand out strongest to me. The unity of hundreds, even thousands of artists who banded together for *Manifest Hope* to provide a visual impetus for Hope and Change is very inspiring to me. After all, as artists we are responsible to the masses for providing the visual language that ultimately gives us all a common voice.

Patriotism is a more personal ideal, experienced and evaluated in times of crisis or introspection. Individually defined according to experience of self and relationship to country, Patriotism has been whitewashed and perverted by corporate and political powers to mean 'someone who supports his country's authority and interests.' *Manifest Hope* challenges us all to reshape the old definition of Patriotism in light of the global human community and our place within the natural world, allowing us to emerge with a new ideal of 'Global Patriotism.'

Manifest Hope shook the art world and general public awake, forcing everyone it touched to ask critical questions individually and as a group, about our part in redirecting the current path of destruction towards a harmonious existence within the natural world."

ABOVE
Andy Howell
In Change We Trust, **2008**
Enamel on copper coated canvas
36 x 48"

OPPOSITE
Andy Howell
Time, **2008**
Enamel on silver coated canvas
36 x 48"

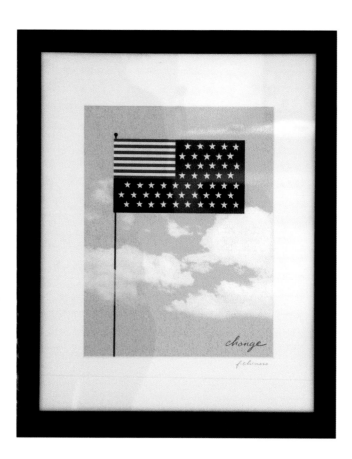

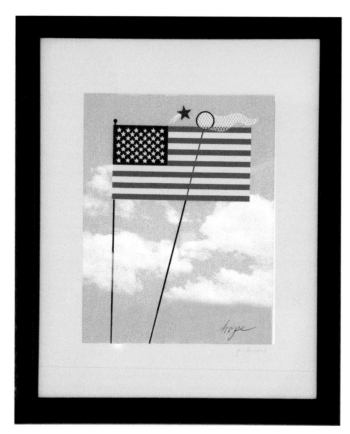

ABOVE LEFT
Frank Chimero
America: Variations on Optimism - Change, **2008**
Giclee and cut paper
18 x 22"

ABOVE RIGHT
Frank Chimero
America: Variations on Optimism - Hope, **2008**
Giclee and cut paper
18 x 22"

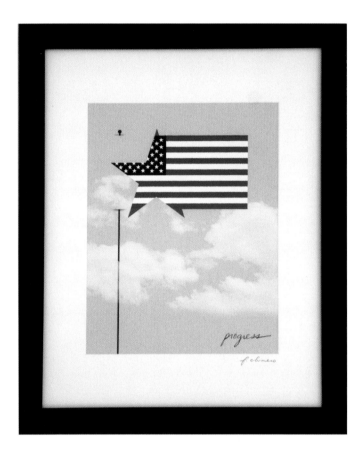

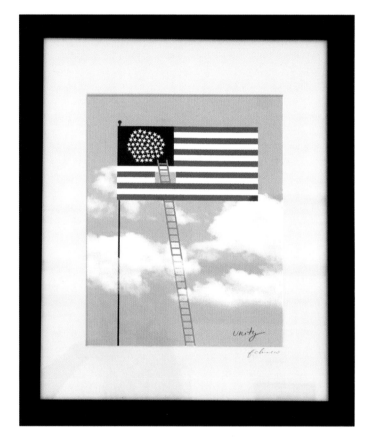

ABOVE LEFT
Frank Chimero
America: Variations on Optimism - Progress, **2008**
Giclee and cut paper
18 x 22"

ABOVE RIGHT
Frank Chimero
America: Variations on Optimism - Unity, **2008**
Giclee and cut paper
18 x 22"

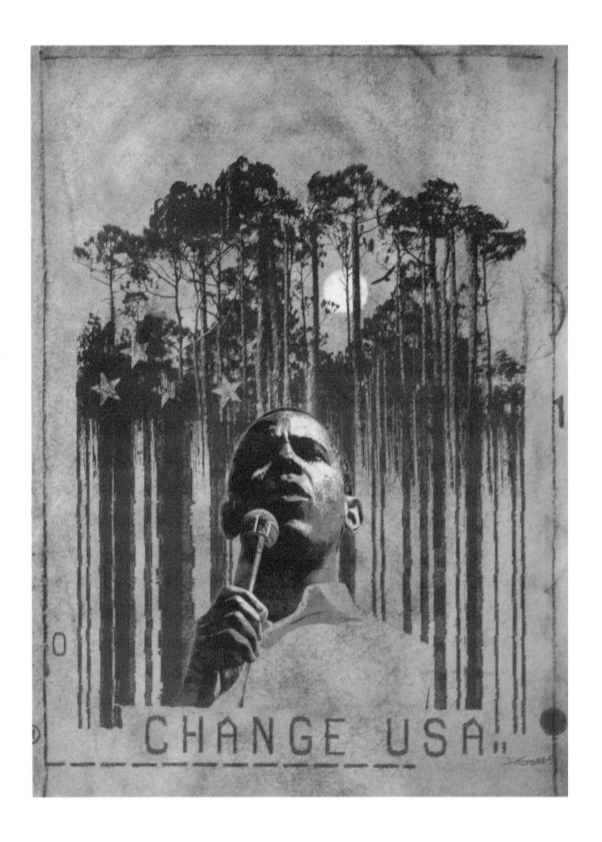

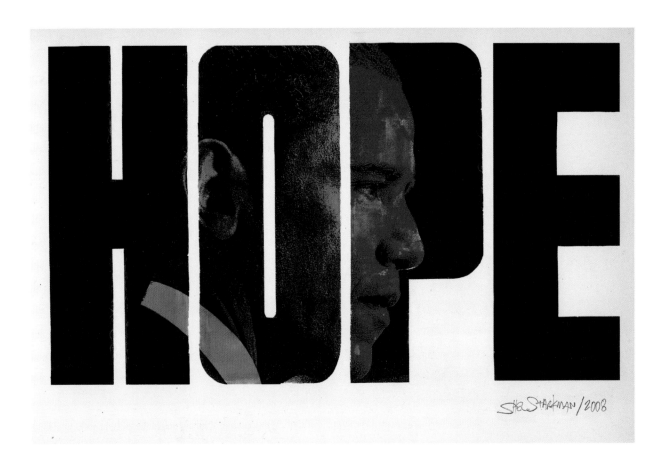

ABOVE
Shel Starkman
Hope / Obama, **2008**
Silkscreen on paper
24 x 16½"

RIGHT
Shel Starkman
This Is Our Moment, **2009**
Acrylic on canvas
40½ x 48"

OPPOSITE
Derek Gores
Change USA, **2009**
Mixed media and digital
on paper
17 x 23"

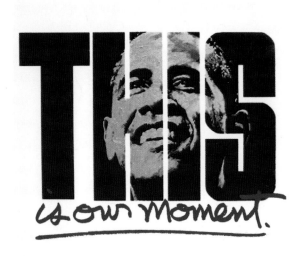

★ ★ ★ ★ ★ MANIFEST ★ ★ ★ ★ ★
RESPONSIBILITY

★ ★ ★ ★ ★ MANIFEST ★ ★ ★ ★ ★
ACCEPTANCE

★ ★ ★ ★ ★ MANIFEST ★ ★ ★ ★ ★
KNOWLEDGE

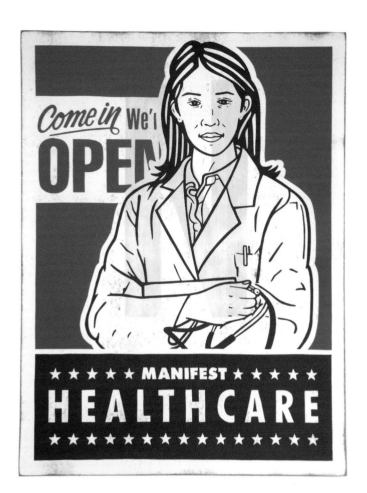

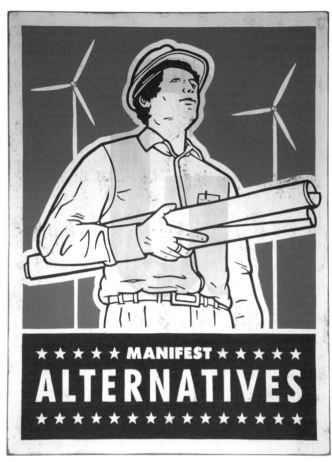

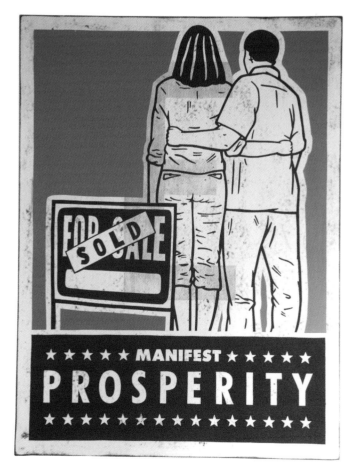

Scot Lefavor
Change, 2008
Spray paint on six panels
36 x 48" each

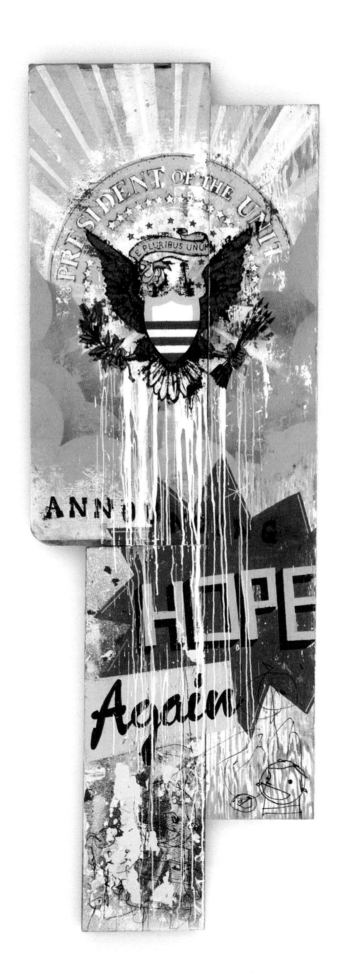

Ales Bask Hostomsky
*Announcing Hope
Again,* **2009**
Acrylic, latex, and stain
on assembled found panel
29 x 85"

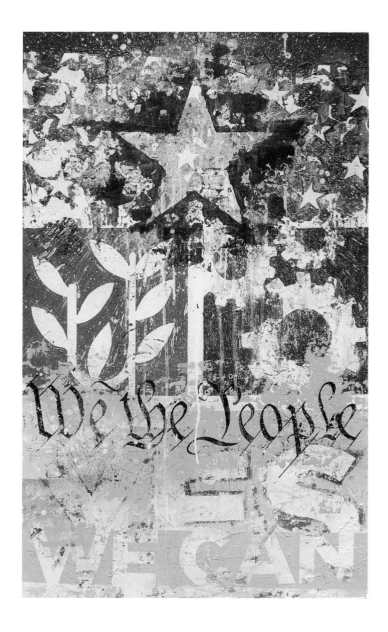

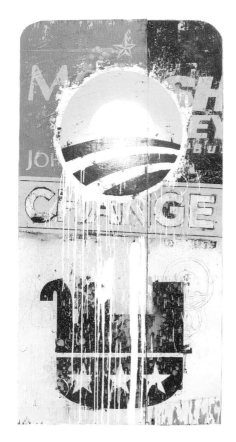

LEFT
Ales Bask Hostomsky
We the People, Yes We Can, **2009**
Acrylic, latex, on wood panel box frame
22 x 36"

BELOW
Ales Bask Hostomsky
Change We Need, **2008**
Acrylic, latex, lacquer stain, and
graphite on found object
32 x 61"

ALES BASK HOSTOMSKY

"In my lifetime, I have never been moved and/or inspired by a leader or public figure. That is until I heard a speech by Barack Obama. The sincerity and passion in his message moved me profoundly, yet I thought that there was no way this man had a shot. He seemed too honest, too real. I suppose, like many, I've become jaded by the system. However, I now see things needed to get as dismal as they did under the Bush administration to create the opportunity for someone like Barack Obama to raise up the expectation level of not only our leaders but also our selves.

In the past year, I've seen the art community united with a common outcry for change and for Obama. The old adage 'a picture is worth a thousand words' sums up the impact that artists had on this past election. I remember I was personally moved to action when seeing Shepard Fairey's now-infamous campaign poster. It was so obvious that us, being artists, have an impact on popular culture unlike anybody else. The *Manifest Hope* exhibits in Denver and DC were extraordinary examples of that."

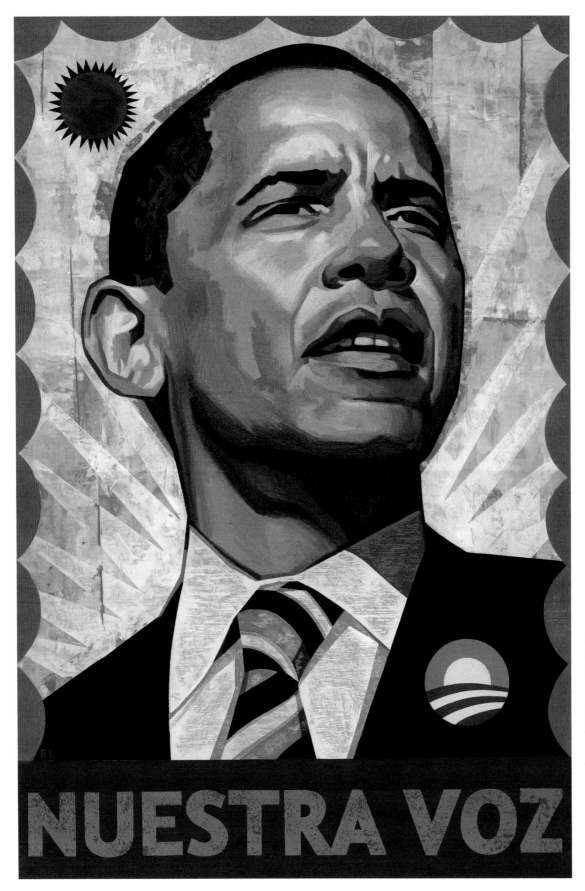

Rafael Lopez
Nuestra Voz, **2008**
Acrylic on wood
18 x 24"

OPPOSITE
Rafael Lopez
Unidad, **2008**
Acrylic on wood
18 x 24"

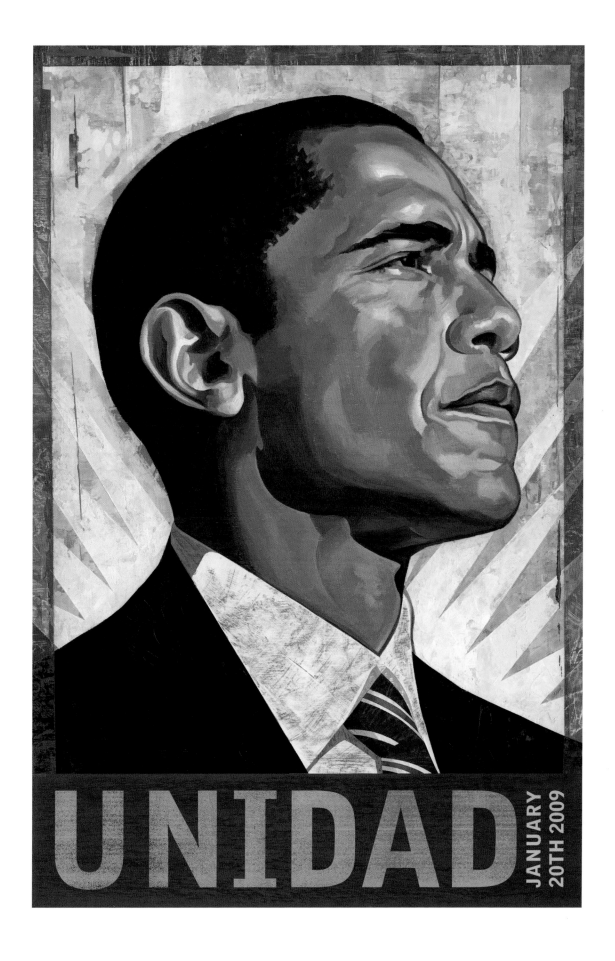

JANUARY 20TH 2009

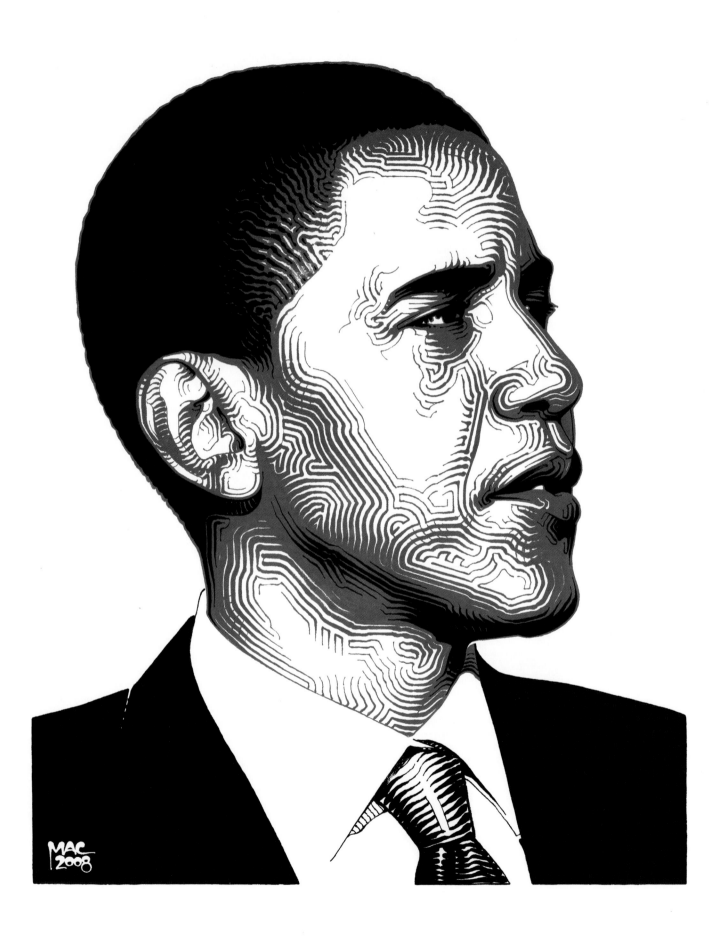

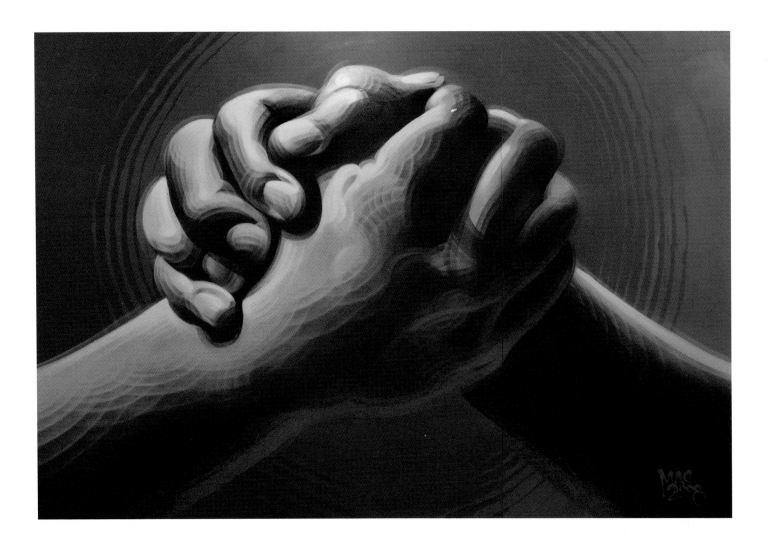

El Mac
Unity, **2008**
Spray paint and acrylic mural
120 x 120"

OPPOSITE
El Mac
Hope, **2008**
Ink and brush on paper
19 x 25"

EL MAC

"I was really proud to be a part of the *Manifest Hope* show in Denver. It was an amaz-ing experience, very exciting, and definitely felt like a once-in-a-lifetime thing. I feel especially fortunate that I was able to meet so many great people there. I'm not a very social person, and too many egos in one place can sometimes be tricky, but I found it surprisingly easy to get along with everyone involved. I think most of us shared a combination of political frustration and optimism, and we were all express-ing that in a way through our art. Since I had already painted Obama's portrait for a campaign poster at the beginning of the year, I wanted to create a piece with a little broader scope. To best promote the idea of 'unity' I painted the two differently colored hands clasped in greeting, which I thought would be simple, direct, and powerful. I loved painting it, I was blessed with a lot of great feedback, and I felt honored to be showing alongside such cool artists. Denver was a perfect place for all of this, very supportive. There was so much energy there that even after painting my piece for the show I was still able to go out and paint a couple murals in the city with some friends AND go shoot some guns."

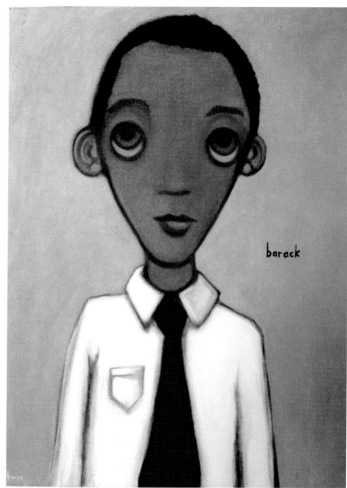

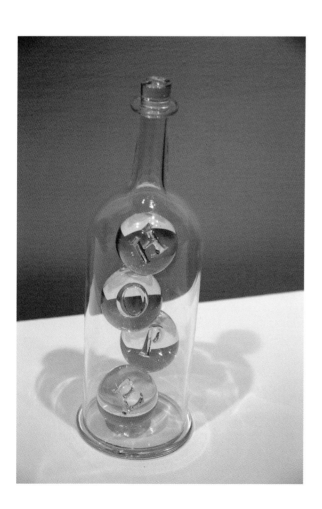

ABOVE LEFT
Van Taylor Monroe
The Obama Shoe, 2008
Acrylic on Nike
Size 12

ABOVE RIGHT
Jeremy Charles Burns
Barack, 2008
Acrylic on canvas
18 x 24"

LEFT
Marc Petrovic
Potion Bottle–Hope, 2009
Glass and air
4 x 12"

Cori Doherty
Beyond Petroleum, **2009**
Pine, steel, and flora
96 x 96 x 360"

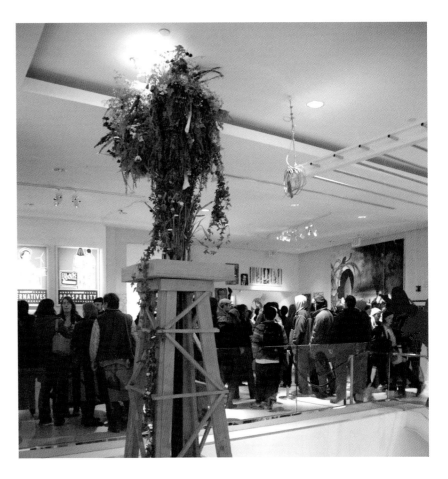

CORI DOHERTY

"Participating in *Manifest Hope*: DC as an artist was a pretty incredible experience. Floral design is often overlooked as an art form—sure, flowers are pretty, but few people would refer to an arrangement as art. I hope this piece helped to change that perception and, in my mind, that's what this campaign was all about: using nontraditional methods to convey a message.

Five and a half feet of cut flowers and live plants were crafted to look like an oil gusher set atop a thirty-foot derrick, as an installation to represent the Green Economy, which, along with Health Care Reform and Workers' Rights was one of the three themes of the gallery.

More important than the piece itself was how it came together. This vision was brought to life in collaboration with Yosi Sergant, Michael Murphy, and his amazing team of artists, who used their talents to build the derrick and the base frame for the flowers. It took more than fifteen people working together to position the base— covered with flowers—on top! There was such a spirit of teamwork as the gallery took shape throughout the week; artists, staff, volunteers, and friends worked, shared, and helped each other to bring this once-in-a-lifetime experience to the public.

This, too, was in many ways similar to the campaign for Barack Obama. Embracing common ideals, people came together, offering whatever they had—money, voices, time—to elect a man who cares about the issues that are most important to us. Artists participated in the way we know best, through our artwork, leaving indelible images of a beautiful, historic time to last the ages. I am proud to have been a part of that."

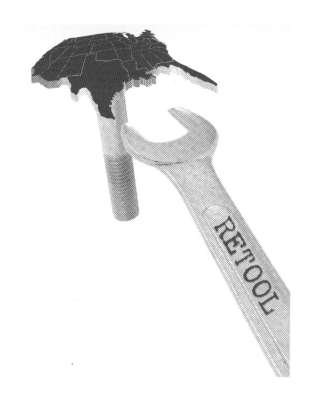

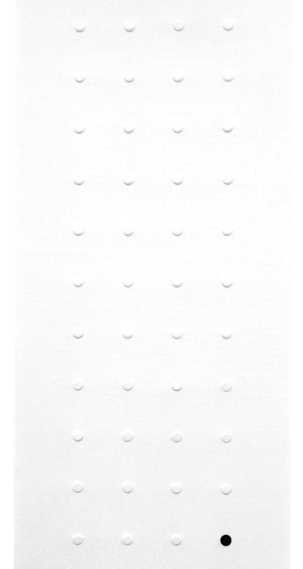

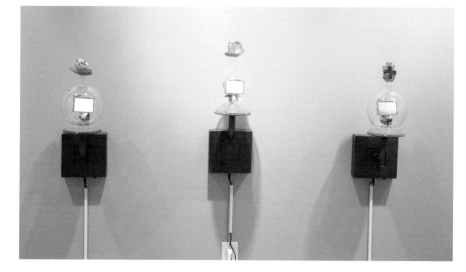

RIGHT
Nicholas Dewar
Yes, **2008**
Acrylic on board
14 x 23½"

OPPOSITE ABOVE
Shannon Moore
Retool America, **2009**
Silkscreen on Arches Cover
12½ x 17"

OPPOSITE BELOW RIGHT
Tim Tate
Heatlh Care Reform
Stabilized at Last,
Workers Rights Work=Dignity,
Green/Environment Issues
Let the Healing Begin, **2009**
Blown and cast glass,
electronic components, video
12 x 6 x 6"

OPPOSITE BELOW LEFT
Michael Jacob
Obama 44, **2009**
Hand—embossed dots, with
last dot hand—colored, on
Strathmore 400 Bristol board
12½ x 30"

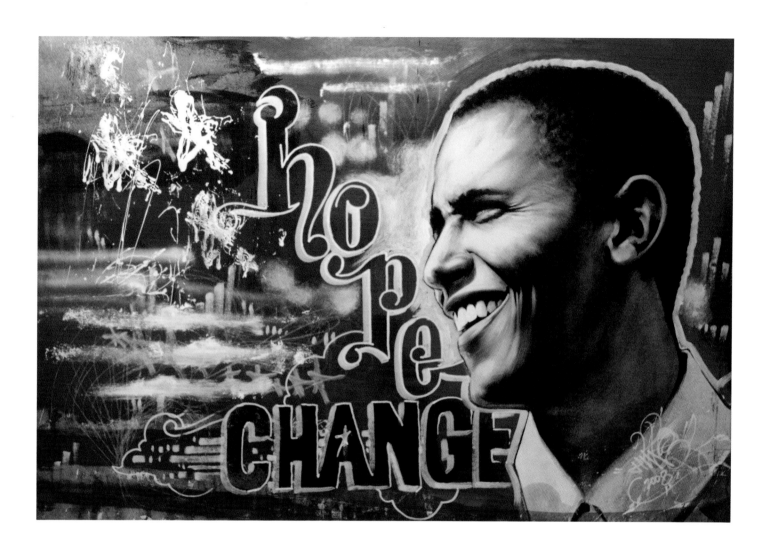

HVW8

"People ask why I was so supportive about Obama when I'm a Canadian and can't even vote in the U.S. Well the short answer—it's pretty amazing! Since I have lived in the U.S., people living outside the U.S. would always criticize America and its politics. It was deserved, but at the same time the Bush administration and his policies didn't represent the America I know and love. Now you have Obama—and only in America could you have such a amazing almost instant transformation stemming from a individual with such massive ramifications. I feel that America is 'Good' again, and with everything that has been happening with the world economy and events, it demonstrates how interconnected the world is. What is good for here is good for the world. Go bama!"

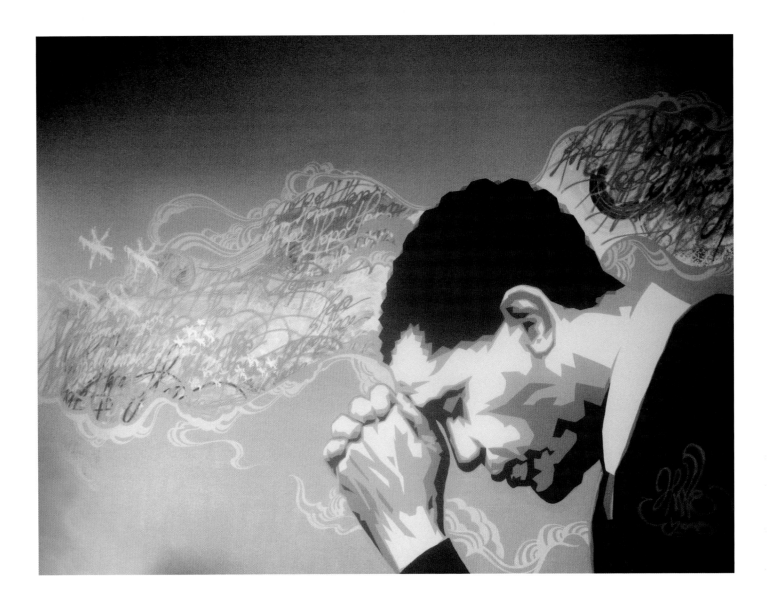

ABOVE
HVW8
Untitled, **2008**
Acrylic and spray paint mural

OPPOSITE
HVW8
Untitled, **2008**
Latex and spray paint
36 x 24"

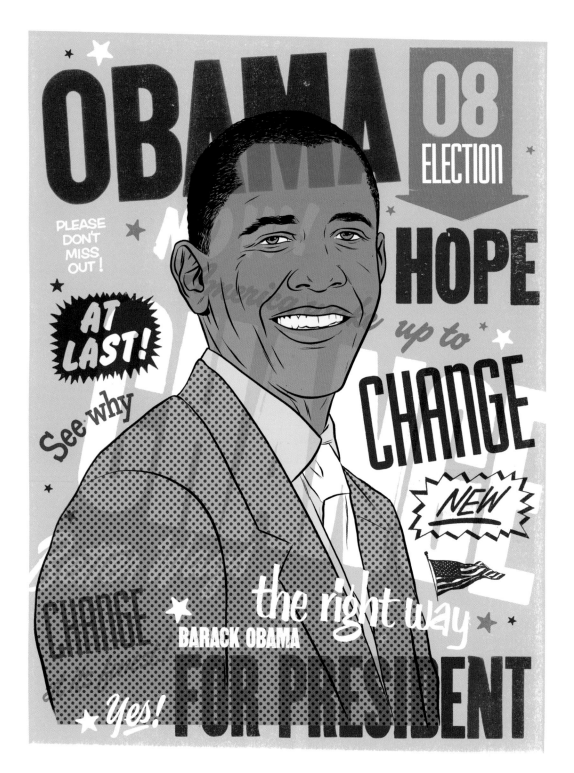

Morning Breath
Obama x Morning Breath x
Upper Playground, 2008
Screen print
22 x 24"

RIGHT
Munk One
Be the Change, 2009
Acrylic on canvas
24 x 36"

BELOW
Munk One
*Obama x Upper Playground
x Munk One*, 2008
Mixed Media on Paper
8½ x 11"

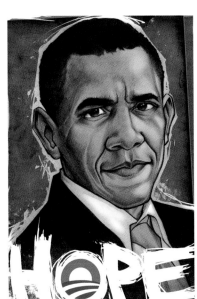

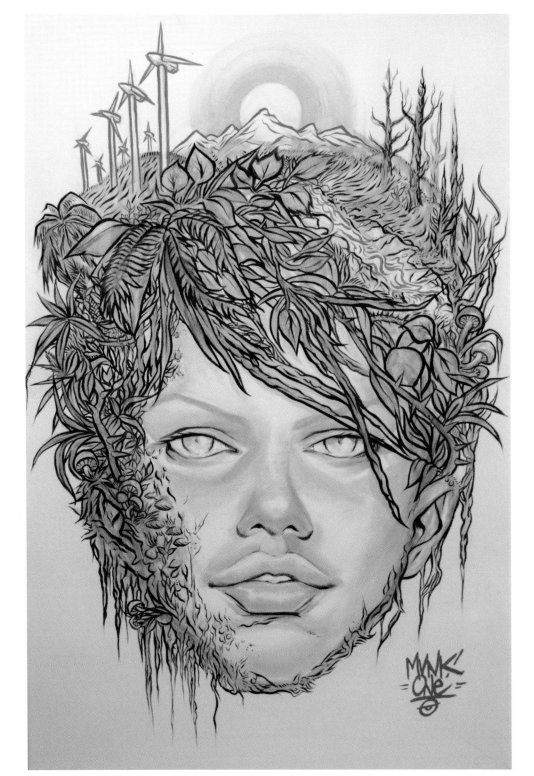

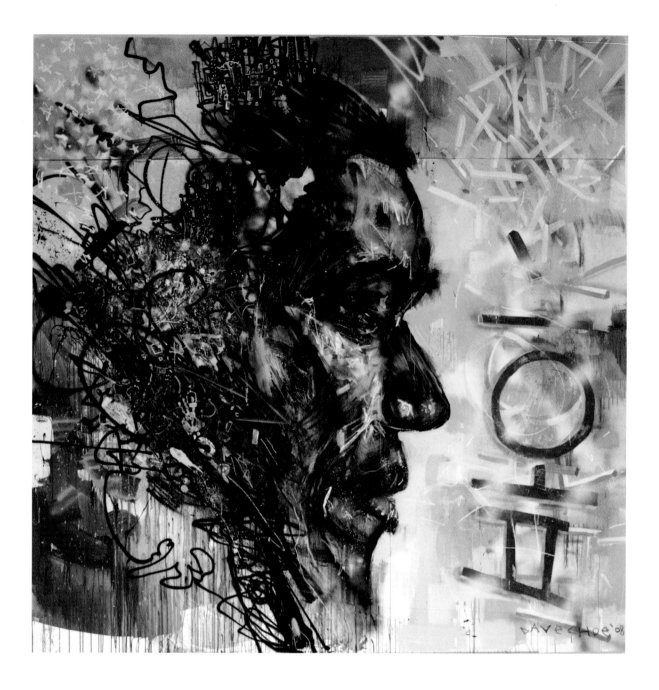

DAVID CHOE

". . . In the beginning it was more of a joke because I was like this guy is never gonna win. But then I got to hear him speak, and found out more about his personal life, and then I started to really like the guy and relate to him—and, really, what do I have in common with any other guy that's ever been president of this country? Nothing. So this was huge for me . . . I'm gonna try and help this guy out the way only way I can, by painting the best fucking painting I possibly can, to capture this man's character, hopes, and dreams into one image."

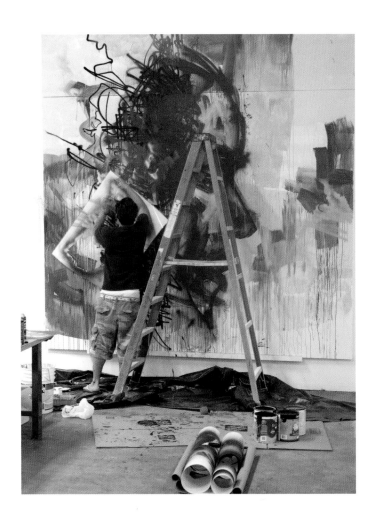

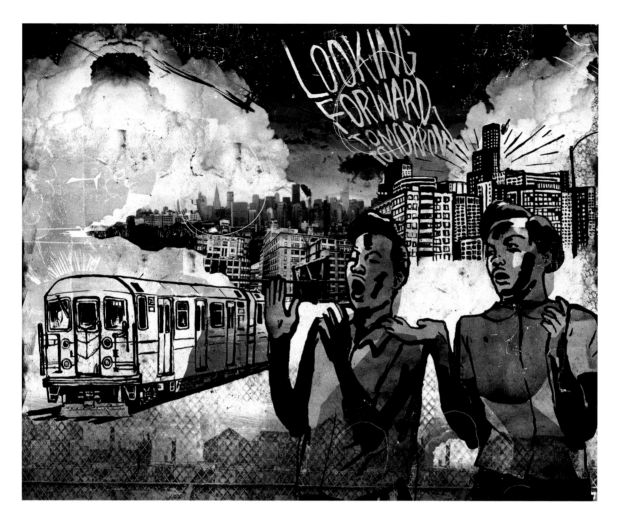

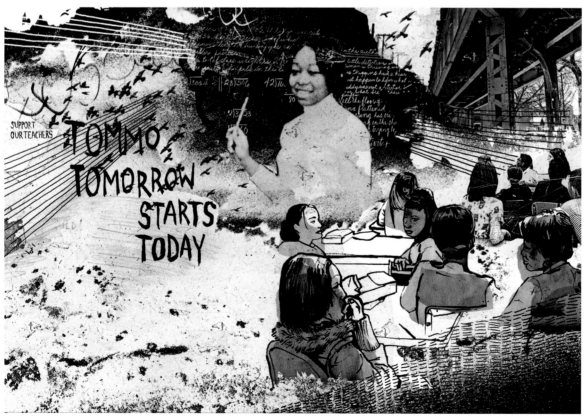

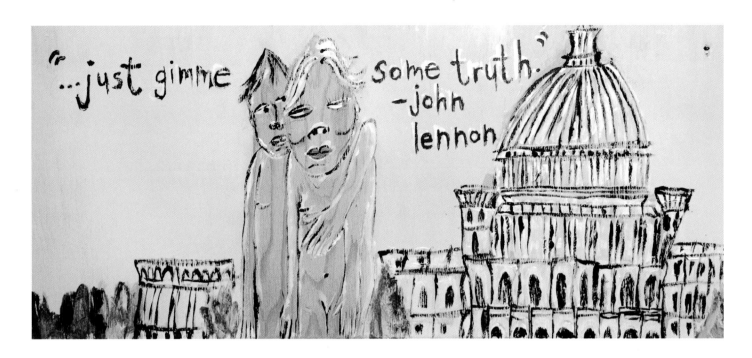

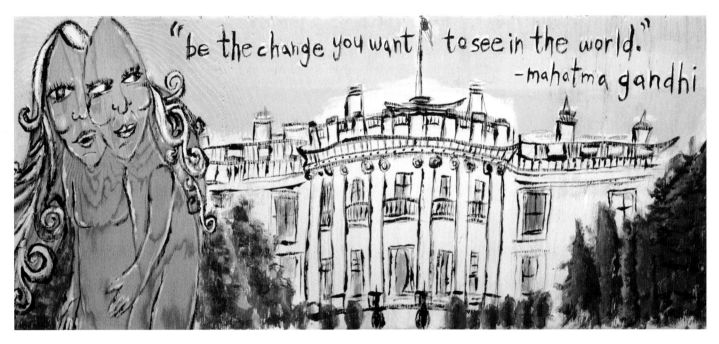

ABOVE
Chris Pastras
Gimme Some Truth, **2009**
Acrylic on wood
18 x 10"

BELOW
Chris Pastras
Be the Change, **2009**
Acrylic on wood
20 x 10"

OPPOSITE ABOVE
Damon Locks
Looking Forward to Tomorrow, **2008**
Digital print on paper
50 x 40"

OPPOSITE BELOW
Damon Locks
Tomorrow Starts Today, **2009**
Mixed media digital print
60 x 40"

THC DRUNK OR NO FEAR

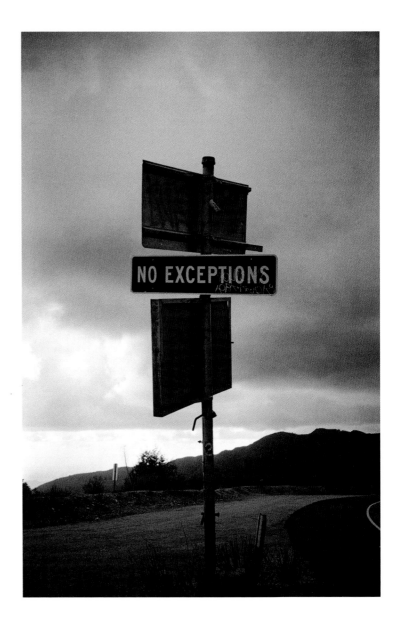

RIGHT
Dan Monick
No Exceptions, **2007**
C-print on paper
17 x 22"

OPPOSITE
Dan Monick
The Drunk of No Fear, **2003**
Latex paint, graphite, c–print,
urethane on panel
19 x 23½"

DAN MONICK

"I have an immense amount of gratitude for being able to take part in both of the *Manifest Hope* shows. I did not attend Denver, but was able to go to the DC show and the vibe and the feel of the show and the surrounding events was absolutely magnificent. I have never seen a coming together of wills and inspiration like I did through these two events. I feel the events completely accomplished what the title declared. Artists of all ilk, disciplines, and styles came together in one force, for one common goal and truly manifested change and possibility; hope, through the actions of creativity and the strength of our beliefs. It was beautiful to witness that, yes, creativity, immense amounts of hard work, and positive thinking can actually affect our world and our place in it."

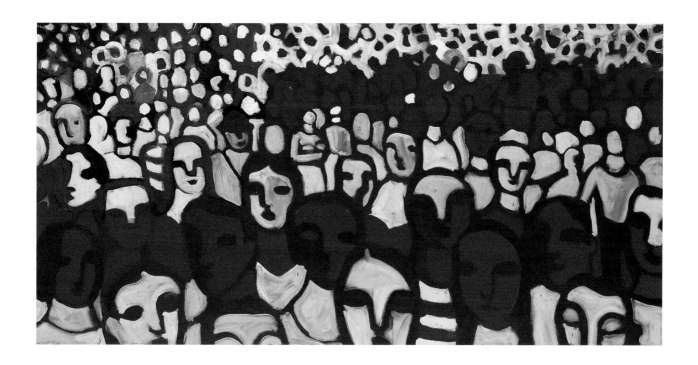

ABOVE
Elizabeth Rosen
We the People, 2008
Acrylic on canvas
48 x 24"

RIGHT
Franke
Hope Obama, 2008
Watercolor paper and
acrylic print
26 x 34"

OPPOSITE
Herb Williams
Obama Portrait, 2008
Crayola crayons
48 x 48"

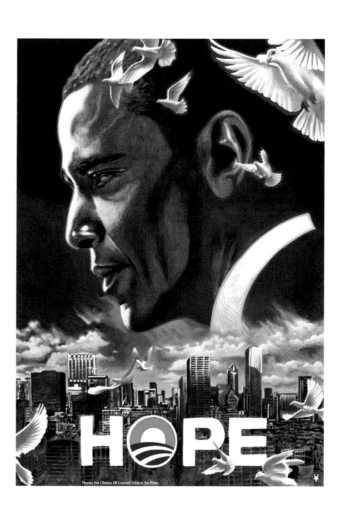

HOPE

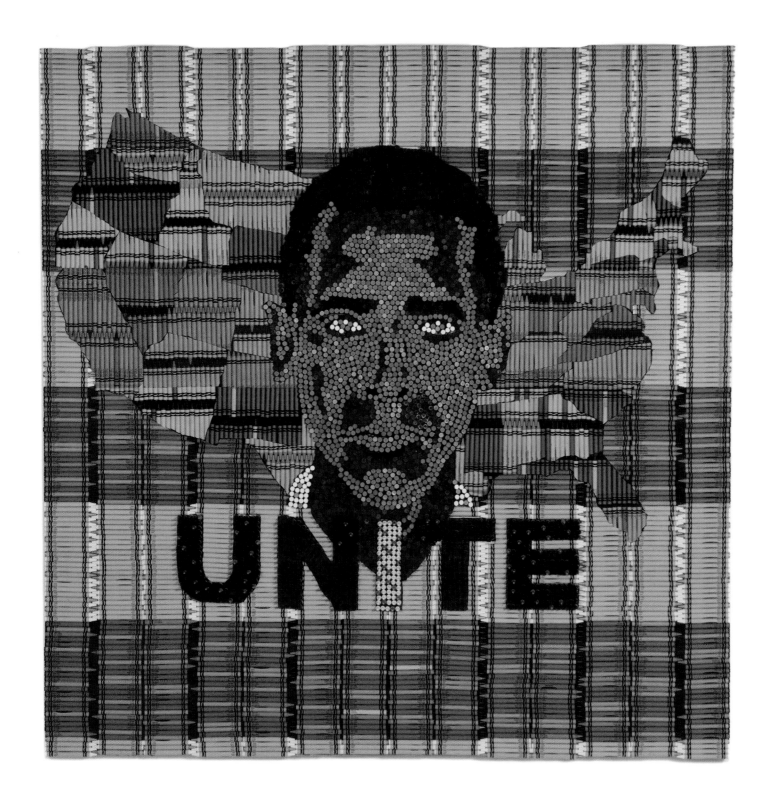

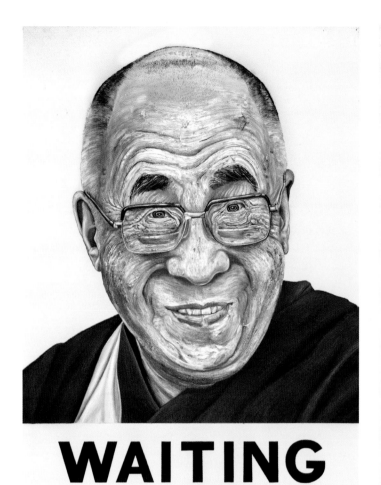

WAITING

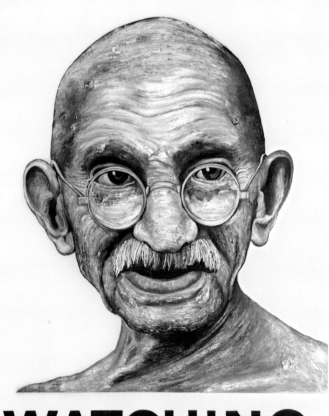

WATCHING

ROBBIE CONAL

"First and foremost: I believe that American Art bubbles up from America's city streets. Big cities, little cities, trailer parks . . . garages. A blast of ozone from enough spray cans alters the molecular structure of the culture. Keeping it real, so to speak."

Robbie Conal
WAITING Dalai Lama – WATCHING Gandhi –
DREAMING Martin Luther King Jr., 2005–7
Triptych of oil on photomontage
60 x 72" each

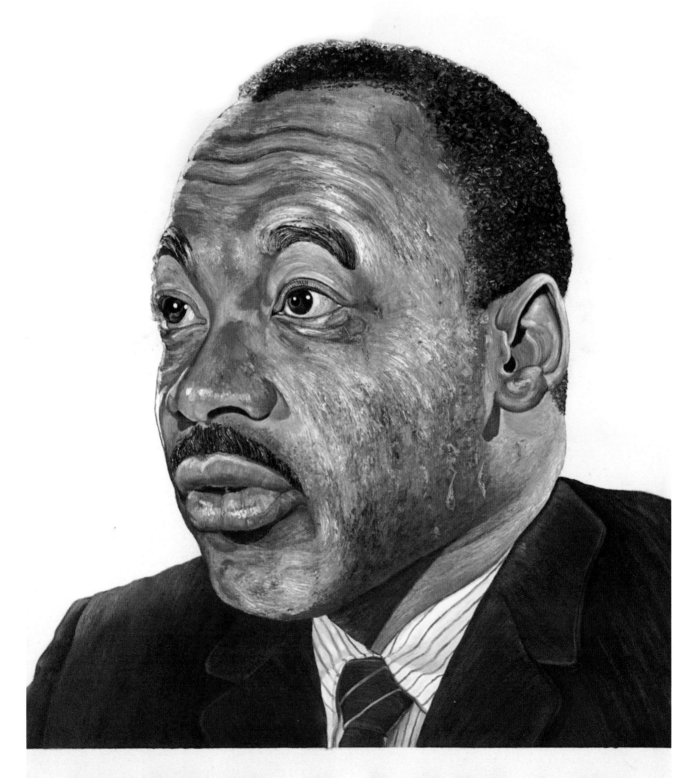

DREAMING

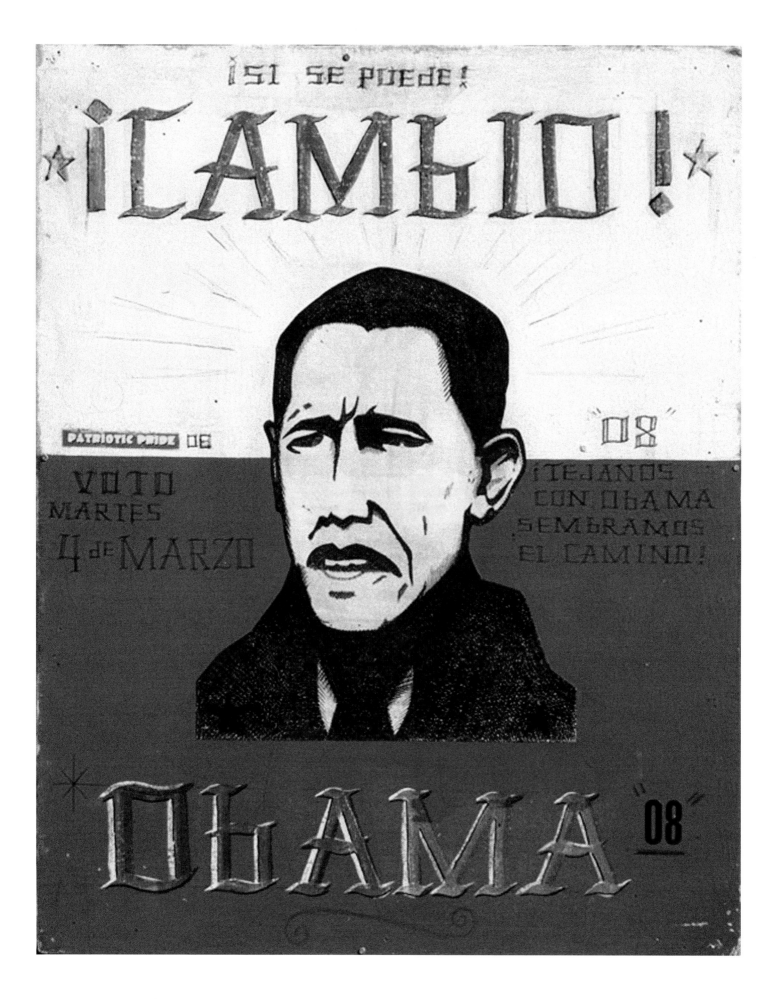

ABOVE
Mike Paré
Freak Flag, **2004**
Graphite on paper
30 x 22"

OPPOSITE
Date Farmers
Cambio, **2008**
Mural, off-set
18 x 24"

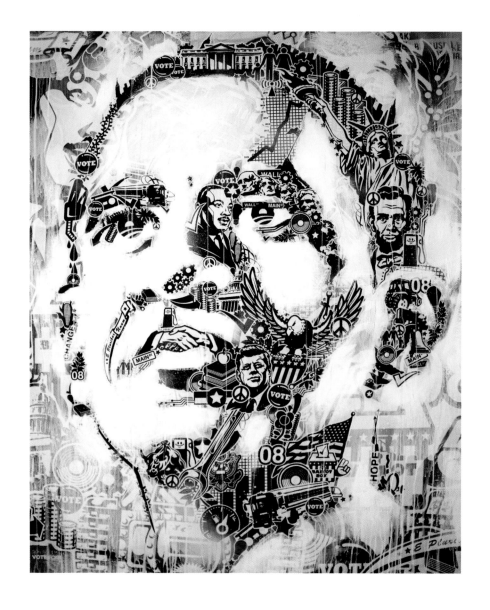

Tristan Eaton
Portrait of Hope and Nostalgia
Mixed media on canvas
48 x 60"

Jorge Arrieta
Workers Unite, 2009
Digital archival print on paper
20 x 34"

Scott Siedman
The Man from Illinois, 2008
Oil on Canvas
20 x 30"

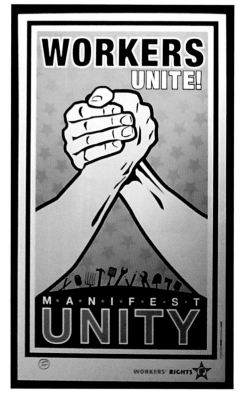

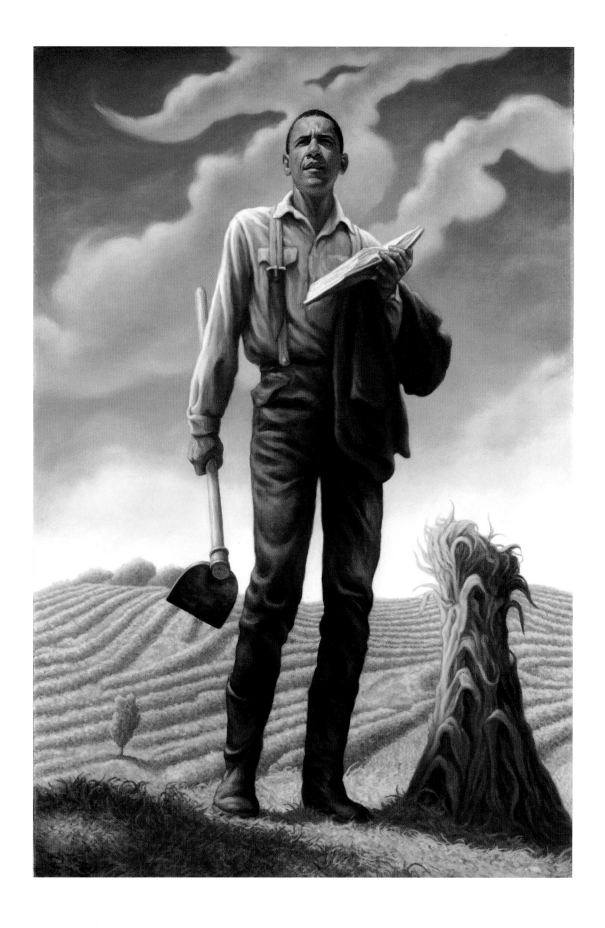

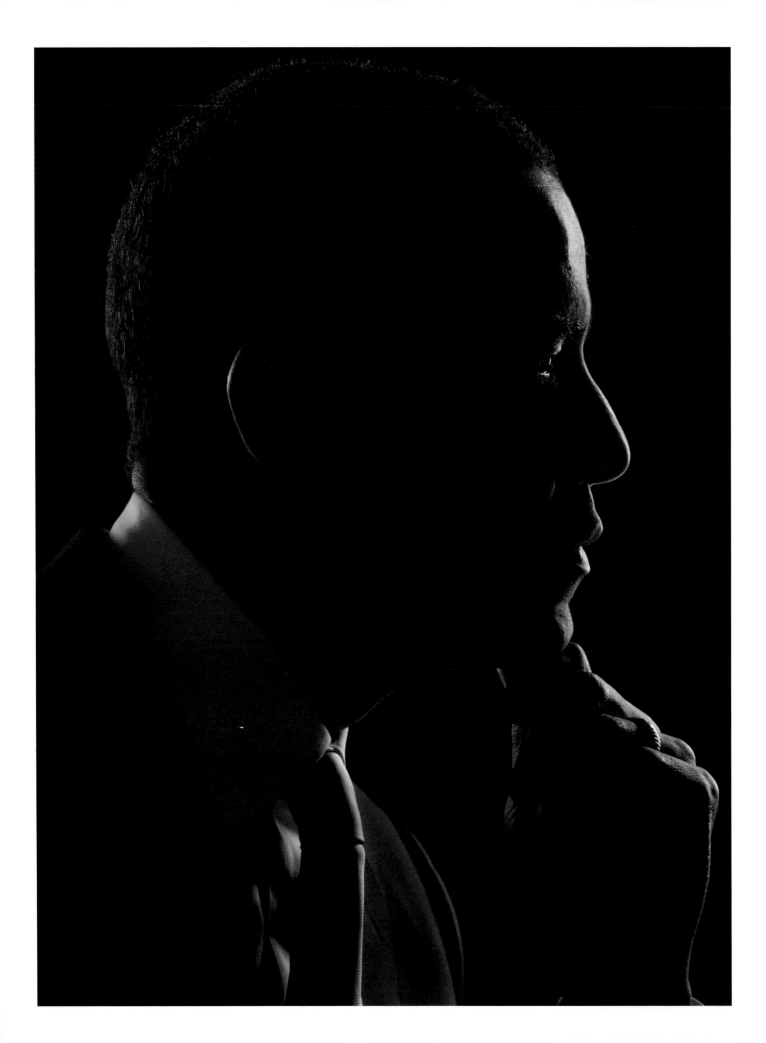

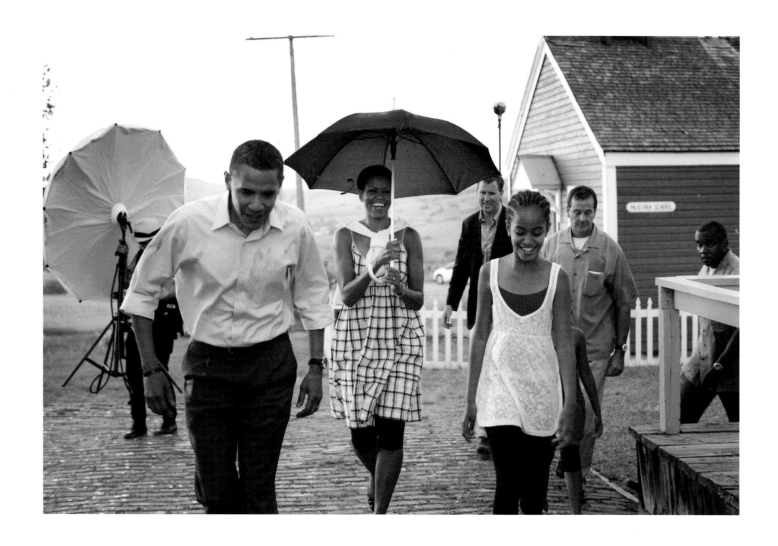

KWAKU ALSTON

"I was fortunate to have the opportunity to photograph President Obama and his family a few times during the campaign.

Due to the significance of the election, I wanted to approach the portraits with a sense of history and purpose. The president and his family are role models for young people, for African-Americans, for anyone who believes in change. It was important to me that the images reflected how strong they are as individuals and as a family.

With the silhouette, I intended to hint at a familiar profile of JFK, the young presidential candidate who is unafraid of the challenges before him. The idea was to revisit the portrait, but to make a shift and try to create a timeless image. The profile lit from the back just outlines the face, without showing race. The goal was to exhibit the power and integrity of his spirit, rather than making another photograph of the first African-American candidate.

It was an amazing experience to spend time with the first family. They have a closeness that is beautiful. It was effortless to highlight the idea that being with his family is a source of joy and security for the president. We were at a Fourth of July parade in Montana and it began to rain. We all started running, the family was smiling—it was a spontaneous moment that captures their grace and warmth.

Hope is an idea, a choice, a feeling. President Obama and his family brought this concept to light again, and have inspired us all to believe in ourselves, our neighbors, our country, and our world."

ABOVE
Kwaku Alston
The Family in the Rain, **2008**
Chromogenic print
24 x 20"

OPPOSITE
Kwaku Alston
Obama Silhouette, **2008**
Chromogenic print
20 x 24"

Kwaku Alston
A Moment of Silence, **2008**
Chromogenic print
24 x 20"

Jayson Atienza
We as One, **2009**
Print on canvas
40 x 40"

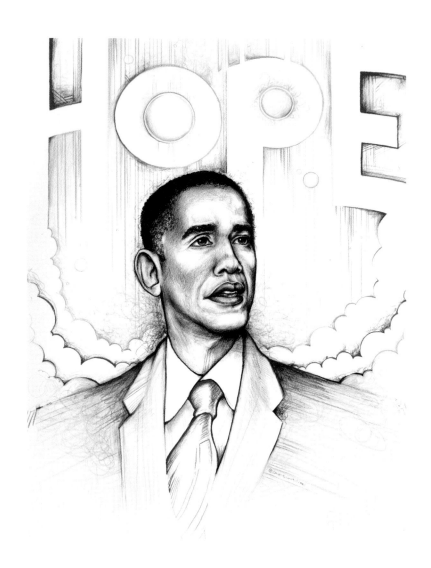

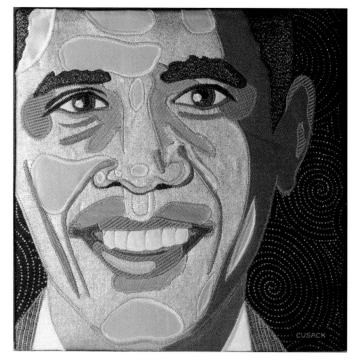

ABOVE
Zach McDonald
Hope (No. 2), 2008
Pencil and colored
pencil on heavy paper
25¾ x 31¾"

RIGHT
Margaret Cusack
Obama, 2008
Quilted fabric
12 x 12"

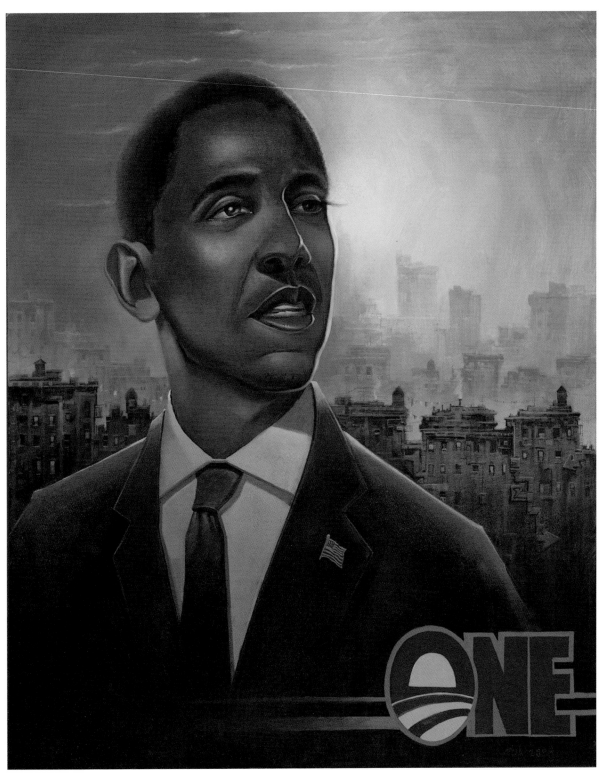

Justin Bua
OBAMA: A New Day, **2008**
Acrylic on canvas
24 x 30"

JUSTIN BUA

"As an artist of the people, the 2008 election was the first in which I witnessed the Hip-Hop generation inspired to activate our collective political voices. Artists, rappers, B-boys, and MCs were a part of both the grassroots and mainstream mobilization that helped to win the election. My painting, *OBAMA: A New Day*, captures the sun rising on the urban cityscape. It signifies a new era in the sociopolitical world order with President Obama leading ONE movement."

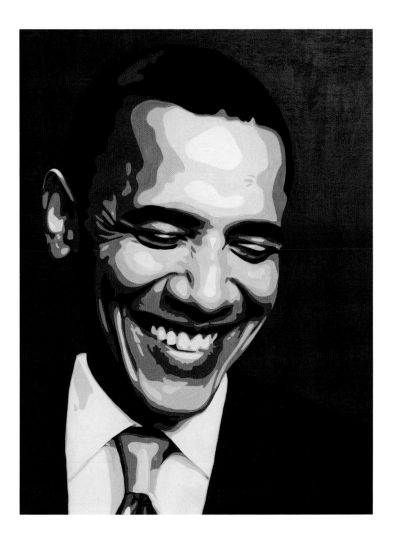

ABOVE
Aaron Axelrod
***Declaration of Independence*, 2008**
Oil on wood panel
36 x 48"

LEFT
Aaron Axelrod
***Obama*, 2009**
Gouache on panel
36 x 48"

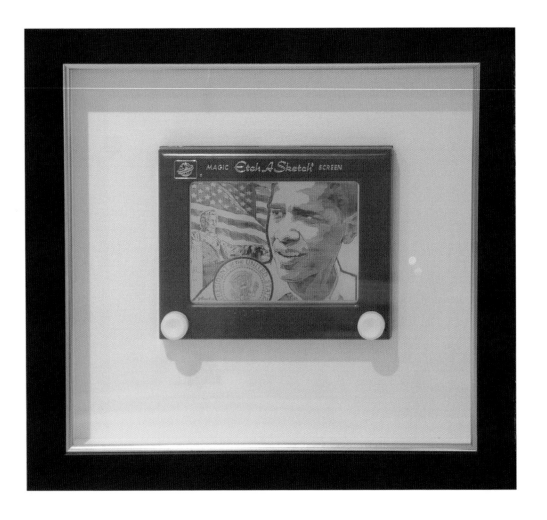

ABOVE
George Vlosich
***Kings and Presidents,* 2009**
Etch A Sketch
20 x 19"

RIGHT
Emek
***Obama Bomaye,* 2008**
Silkscreen
24 x 34"

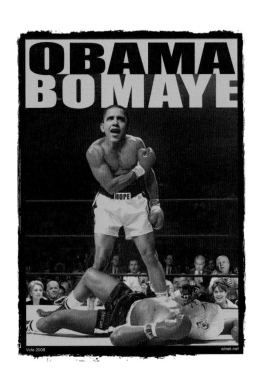

Tim Biskup
With Poetry and Grace, **2009**
Acrylic on MDF Panel
10 x 24 x 18"

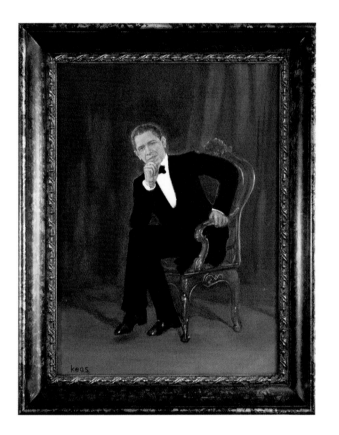

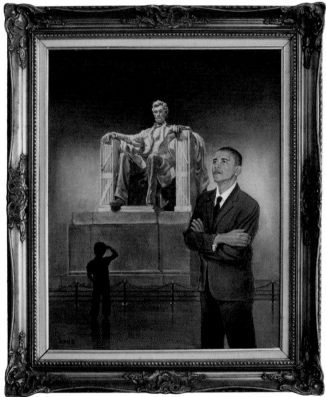

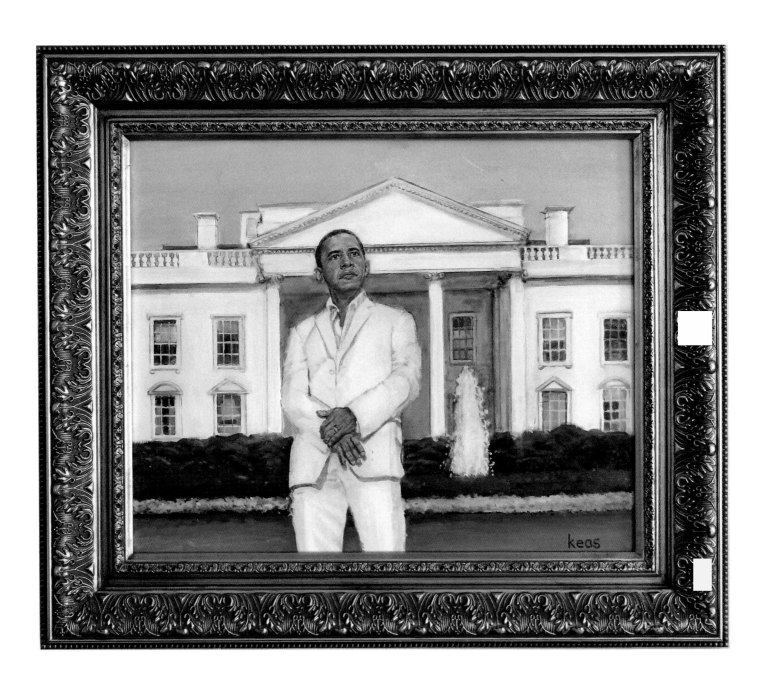

Ron Keas

Fountain of Hope, **2008**

Oil on canvas

26 x 23"

ABOVE LEFT
Ben Dutro
Embrace for the White House, **2008**
Digital Illustration
12 x16"

ABOVE RIGHT
Jason Dletrick
Freedom, **2008**
Digital print with archival ink
on German etching paper
24 x 36"

LEFT
Lisa M. Regan
Signpost for Change, **2008**
Steel
42 x 102"

Chris Gardener
House Industries 44, **2009**
Ink and brush on paper
14 x 17"

BELOW
Elisabeth Fried
Obama For "Change," **2009**
Digital print on paper
35 x 25"

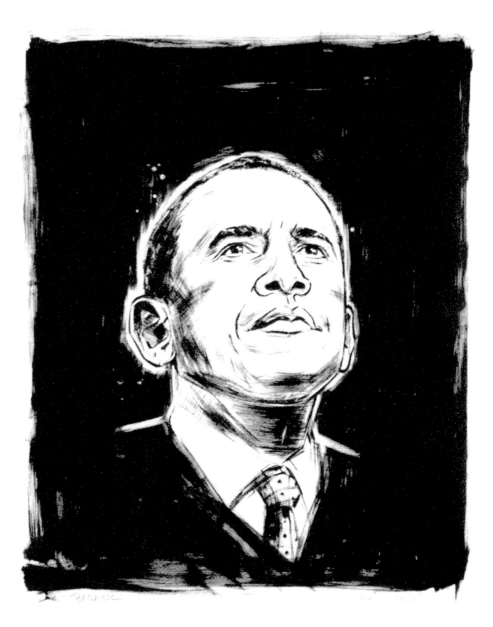

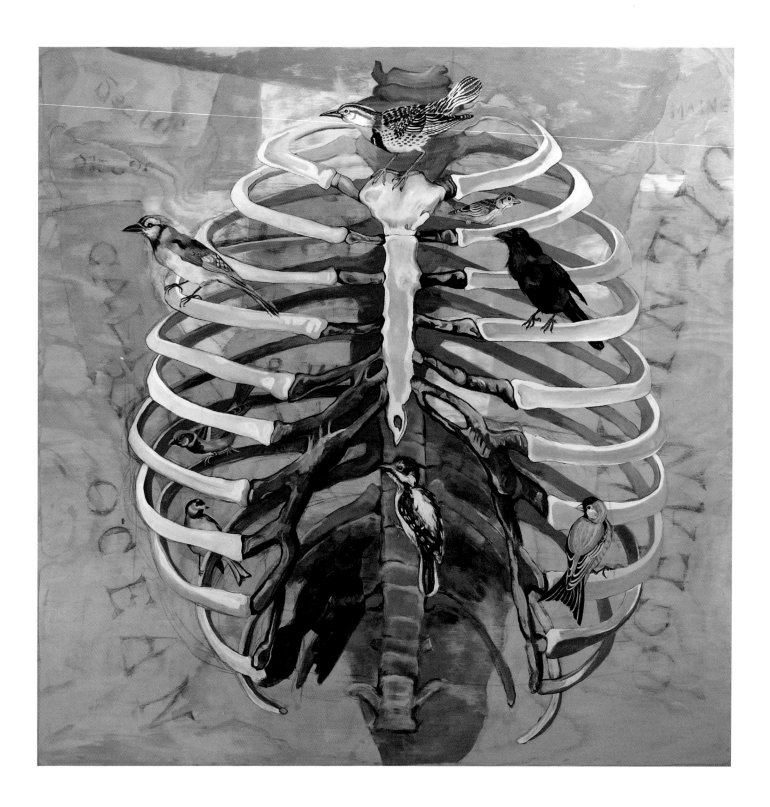

Kay Tuttle
Cage, 2008
Acrylic on wood
48 x 48"

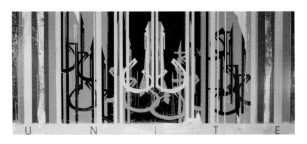

ABOVE LEFT
One 9
Lanugage of Mystics–Unite, **2009**
Paper, acrylic, and enamel on Sintra board
48 x 22"

ABOVE RIGHT
Kenji Hirata
Idvsbl x 4 (Universal Appeal 4), **2008**
Acrylic on wood board
12 x 12"

LEFT
Travis Lampe
New Factory, **2009**
Acrylic on illustration board
5½ x 7"

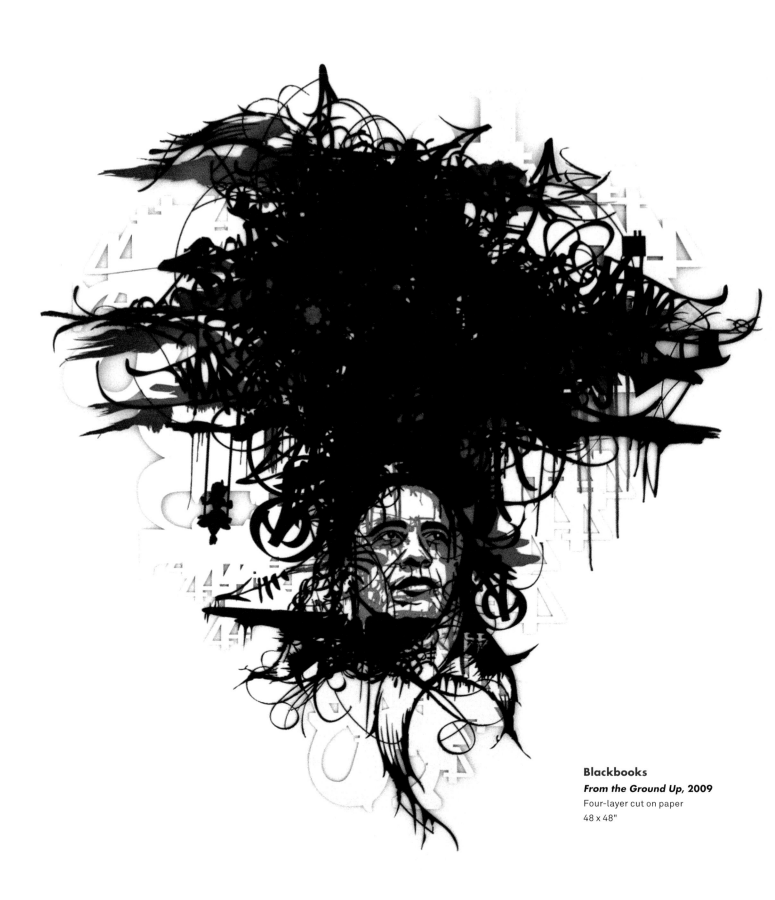

Blackbooks
From the Ground Up, **2009**
Four-layer cut on paper
48 x 48"

RIGHT
Felix Jackson, Jr.
Yes, Please, **2009**
Screen print on cream stock
18 x 24"

BELOW
Felix Jackson, Jr.
A Guy Named Barack, **2009**
Acrylic on two canvases
18 x 24" each

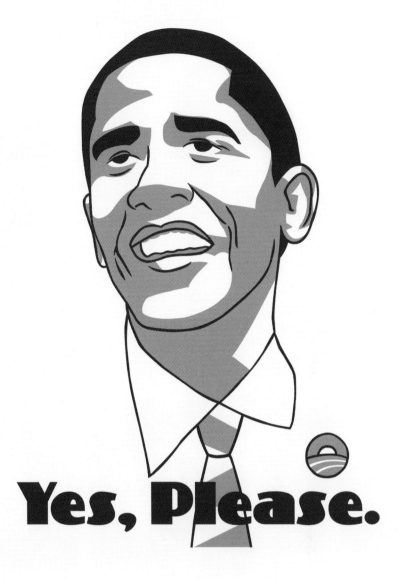

Yes, Please.

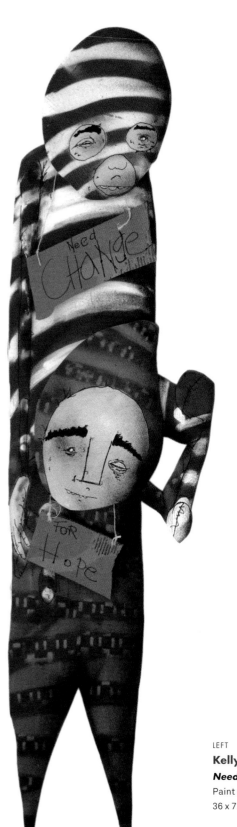

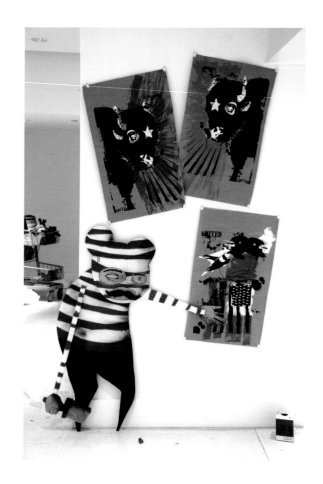

LEFT
Kelly Towles
Need Change! **2009**
Paint and marker on wood
36 x 72"

ABOVE
Kelly Towles
What a brush can do, **2009**
Wood, paint, marker, prints
60 x 120"

BELOW
Kelly Towles
Megan made change, **2009**
Paint, aerosol, and marker on wood
36 x 48"

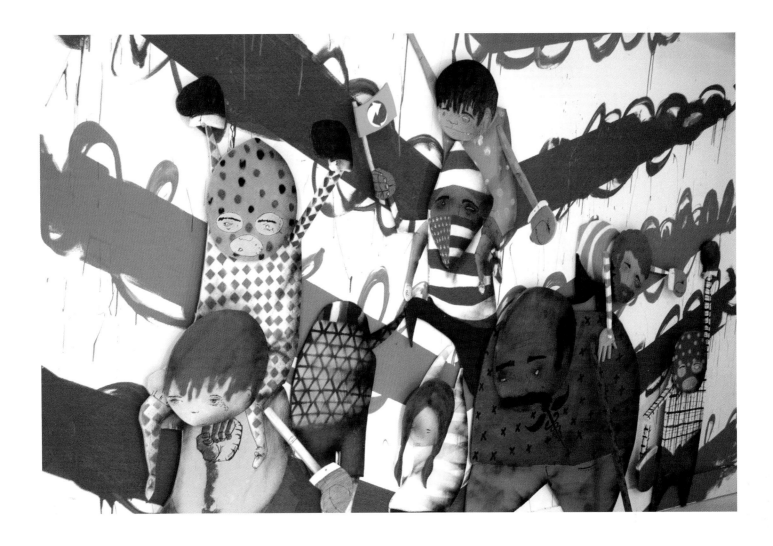

KELLY TOWLES

"There are points in your life where you take a mental snapshot, where you really feel something warm inside. It may sound like complete bullshit, and I don't care. This was what I felt on first night installing the *Manifest Hope* show in DC.

I dumpster-dived to gather almost all the wood to make my work . . . I pulled basically forty-eight hours straight making work, even after I thought I was finished. I was asked to do more. I was tired and I smelled pretty bad.

We are asked to do things and help lend a hand when others won't. Pick up trash and sweep floors . . . and it was my honor to pitch in, not just with the art work, but to lend a hand, to be a leg up, to be part of the change.

If you don't do it, who will? I will. And I will have that warm feeling inside."

Kelly Towles
We are reach for 1 goal, **2009**
Paint, aerosol, and marker on wood
144 x 144"

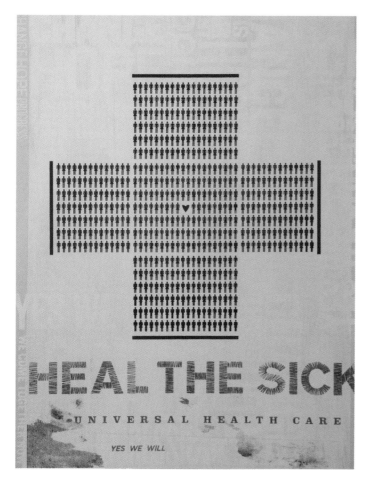

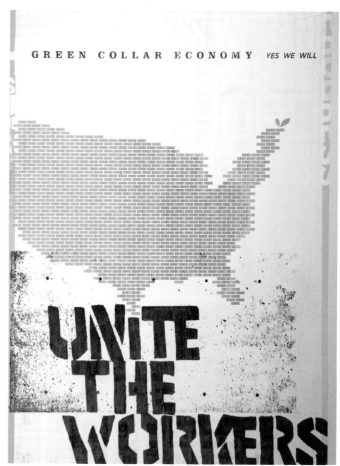

catch the sun

R E N E W A B L E E N E R G Y F U T U R E

YES WE WILL

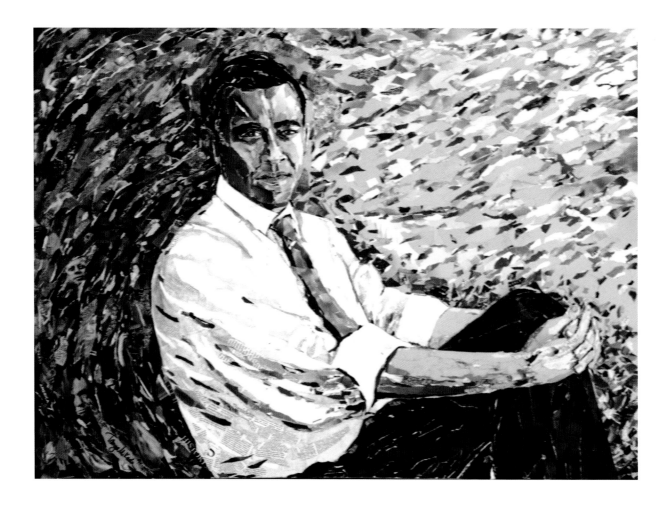

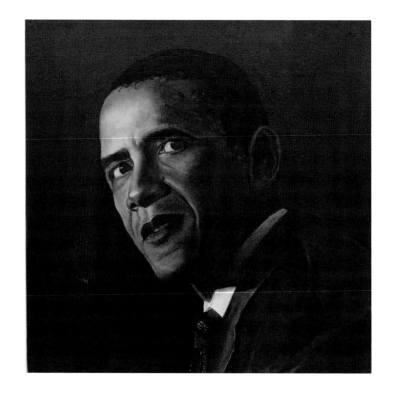

ABOVE
ABOVE
Tanya Mikaela
The Power of Change, **2009**
Collage of recycled torn paper on canvas
48 x 36"

RIGHT
Julie Adler
Untitled, **2008**
Oil on canvas
24 x 24"

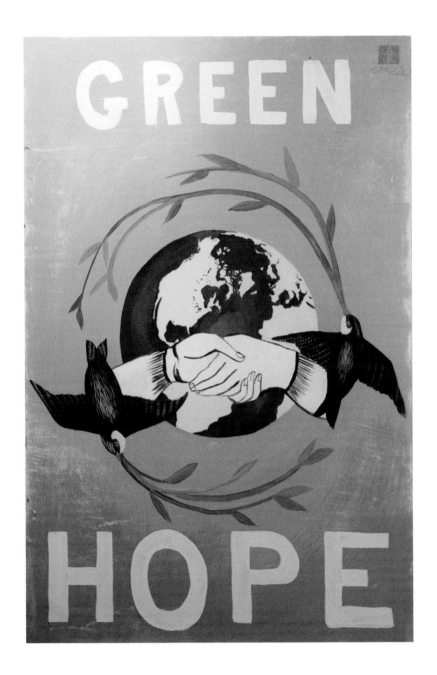

LEFT
Deedee Cheriel
Green Hope, **2008**
Acrylic on wood
18 x 24"

BELOW
Tina Rodas
Hi Mr. Giant, Giant,
Giant Sequoia, **2008**
Wool-felt soft sculpture
48 x 96"

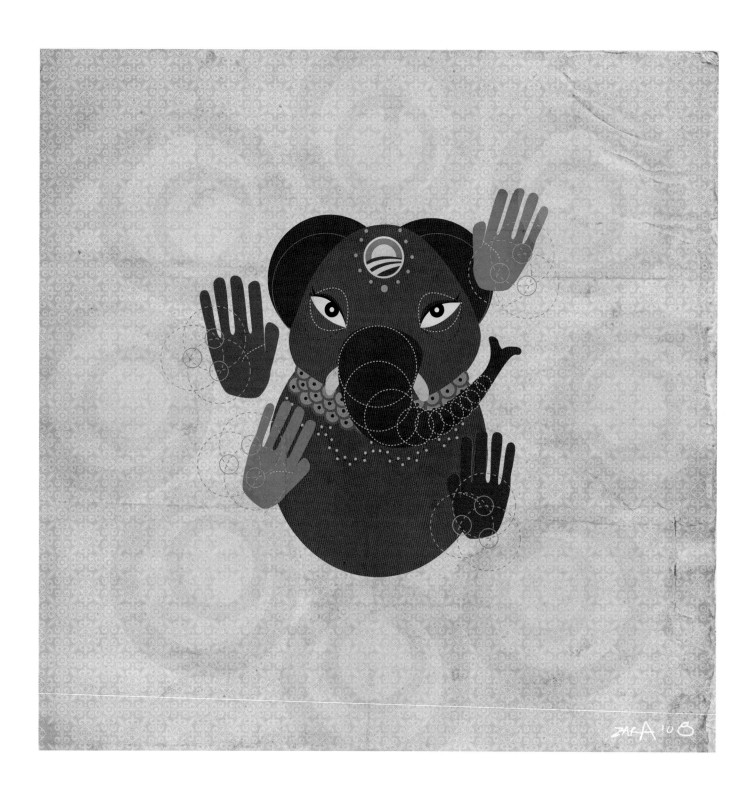

Zara Gonzalez
Obamaphant, **2008**
Digital mixed media
12 x 12"

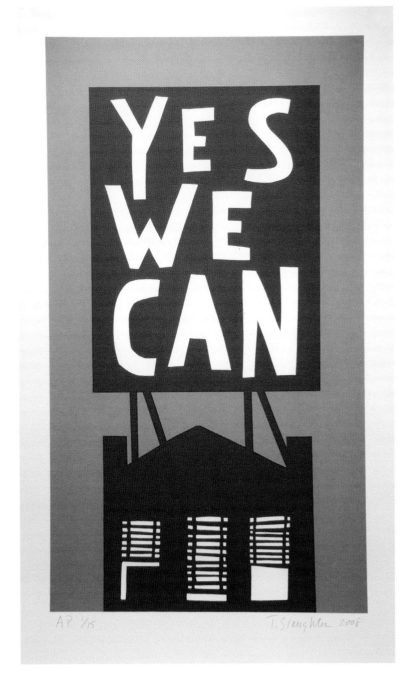

Tom Slaughter
Yes We Can, **2008**
Limited edition silk screen print,
published by Durham Press
20 x 30"

David Lanham
Hope, **2008**
Giclee print on paper and canvas
40 x 48"

LEFT

Larissa Marantz

Unite America, **2008**

Acrylic on canvas

24 x 30"

BELOW

Aaron Allen

Unite the States of America, **2008**

Two-color screen print on paper

31 x 26"

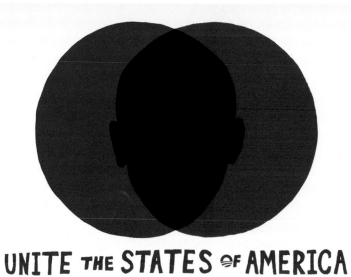

UNITE THE STATES OF AMERICA

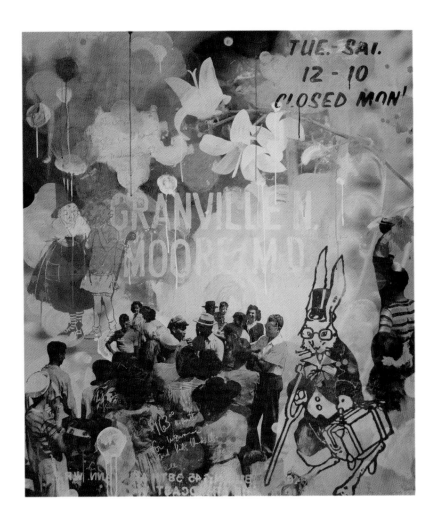

ABOVE
Apak
Greener Tomorrow, **2009**
Gouache on wood panel
18 x 12"

LEFT
Billy Colbert
Sililoquy of Medicinal Mayhem, **2009**
Mixed media on aluminum panel, painting,
and screen printing on photography
46 x 52"

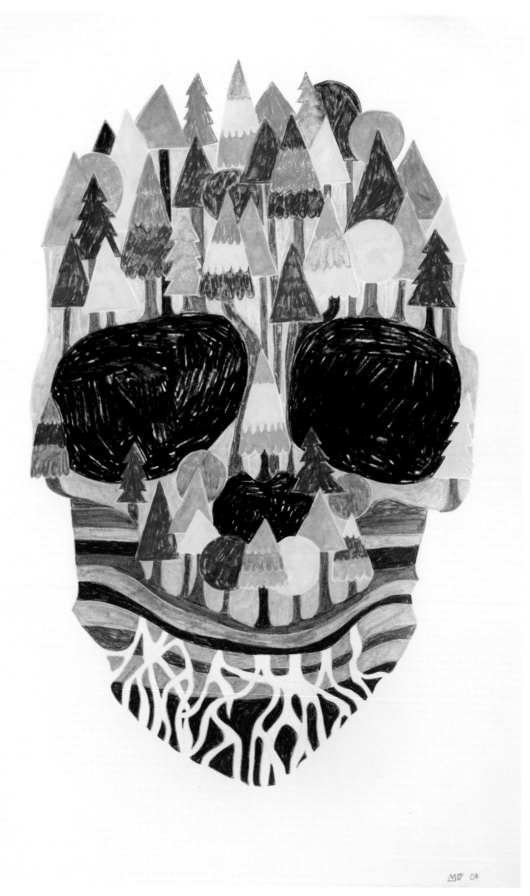

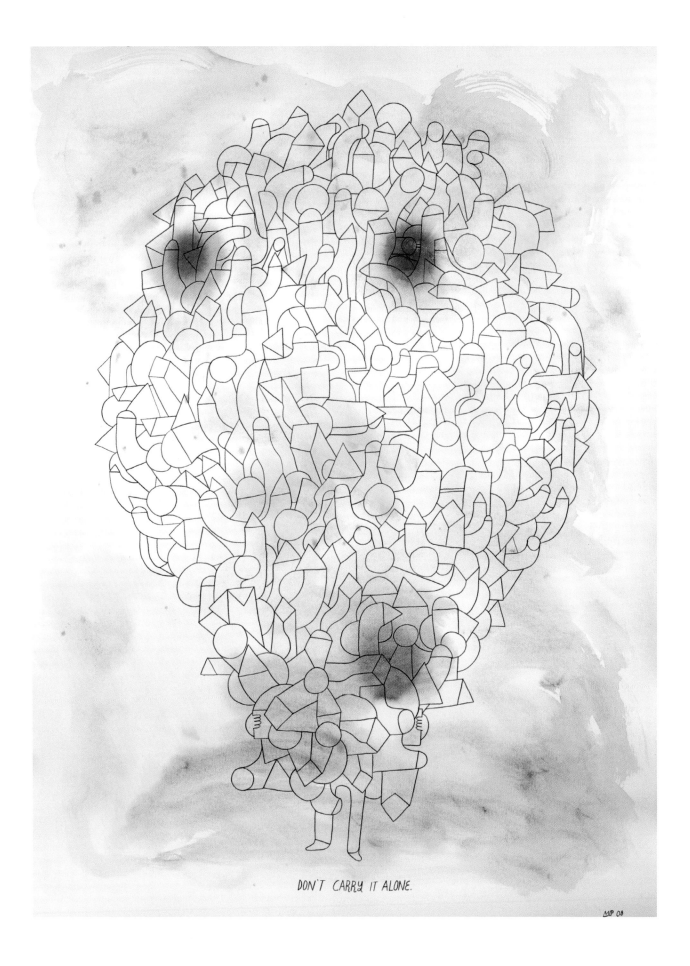

DON'T CARRY IT ALONE.

MP 08

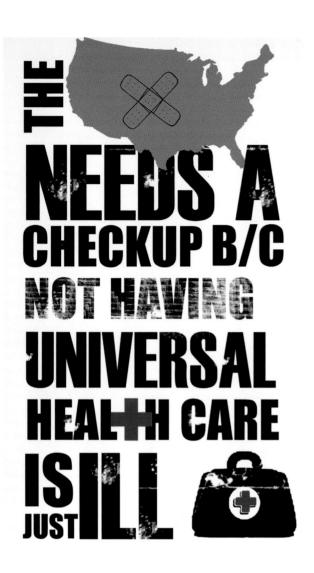

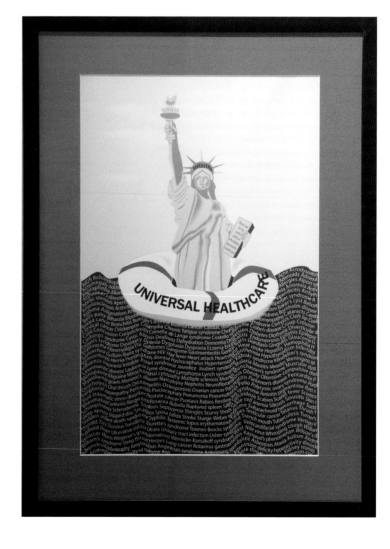

ABOVE
Sharee Taylor
U.S. Healthcare Just Ill, **2009**
Three-color screen print on paper
11 x 17"

RIGHT
Esperanza Macias
Healthcare Equals Justice, **2008**
Digital print on paper
11 x 17"

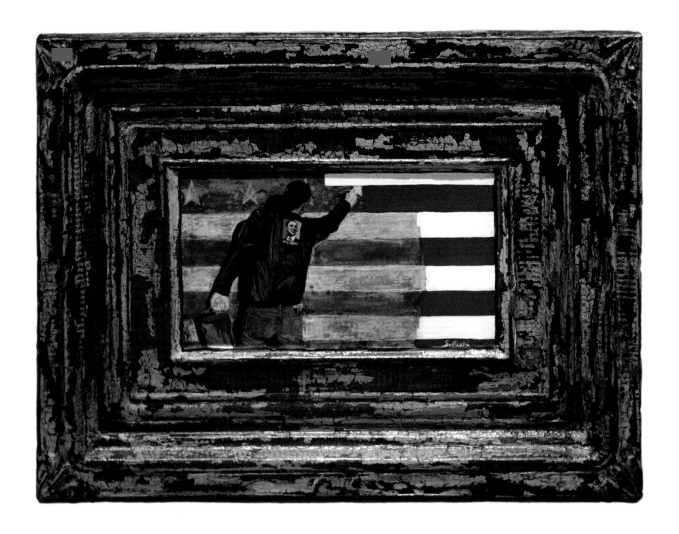

ABOVE
Scotlund Haisely
Restoration, **2009**
Acrylic on salvaged ceiling tin
24 x 18"

RIGHT
Christopher Tucker
Yes. We. Can., **2009**
Print on found cardboard
12 x 18"

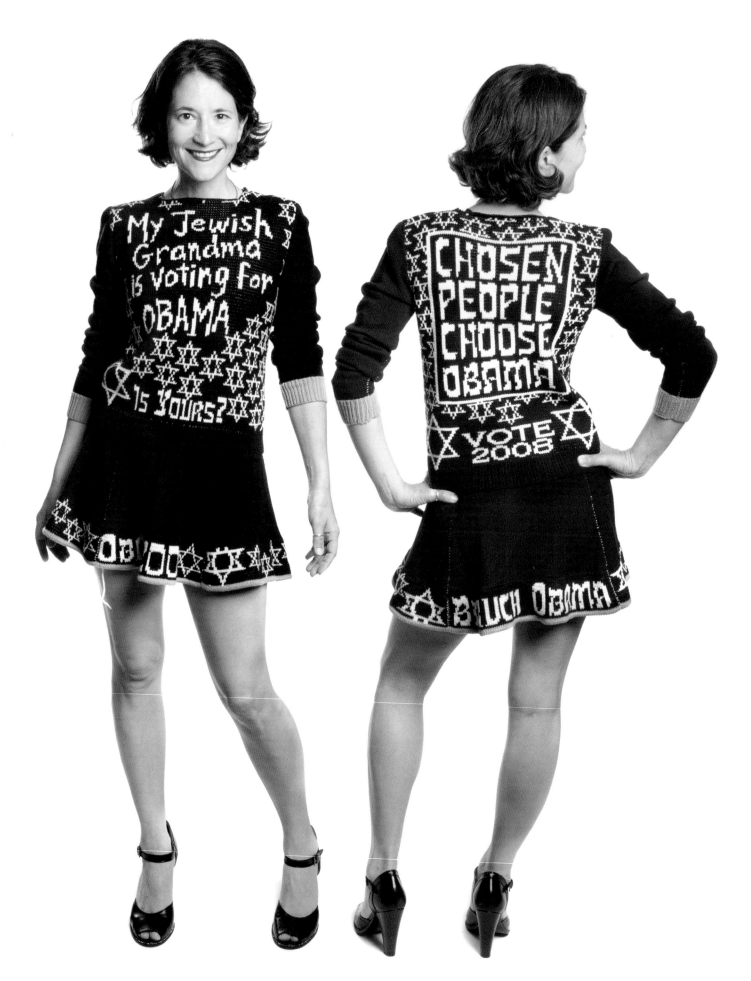

LISA ANNE AUERBACH

"In 2004, I bought a knitting machine and started making sweaters in support of John Kerry. The idea was to make something in support of a political candidate that could be worn to the office, and I was curious about how a sweater rooted in a particular time would feel years later. I still wear those 'Bush is Scary, Vote for Kerry' garments, with a mix of nostalgia and bitterness. I was desperate for John Kerry to win, and four years later, I was even more desperate for Obama to take office.

Wearing a sweater emblazoned with words can be confrontational, but also inviting. There's something non–threatening about a sweater, and I've found that the cozy, homespun quality can attract level–headed conversation in a way that a T–shirt or button might not. Making sweaters in support of Kerry was a pretty lonely pursuit. Even though I started a Web site called 'Knitters for Kerry,' I think I was the only knitter. 2008 was completely different, with the groundswell of support bubbling up everywhere. Patterns for the Obama logo and the word "HOPE" were popping up on knitting Web sites across the Internet; everyone was so inspired. I would have made sweaters about almost anyone running on the Democratic ticket, but I'm really glad it was Obama. It's fun to be an iconoclast, but it's even better to be part of an overwhelming grassroots movement that sweeps a tide of change across the country."

ABOVE RIGHT
Lisa Anne Auerbach
Yes We Can/No He McCain't
(front), 2008
Wool

BELOW RIGHT
Lisa Anne Auerbach
Yes We Can/No He McCain't
(back), 2008
Wool

OPPOSITE
Lisa Anne Auerbach
My Jewish Grandma is
Voting for Obama/Chosen
People Choose Obama, 2008
Wool

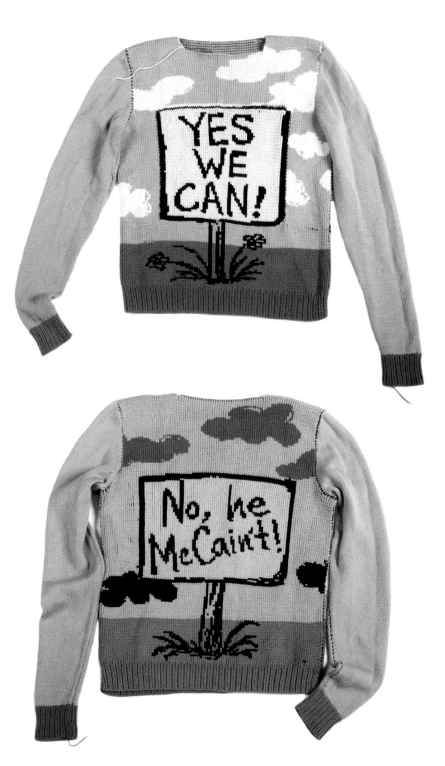

122

Tom Bob
Obama, **2008**
Acrylic on canvas
48 x 36"

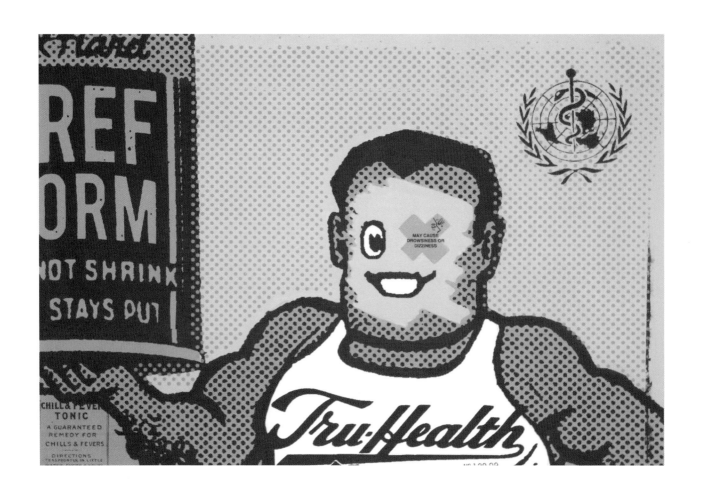

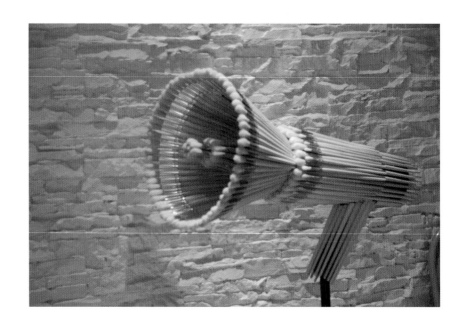

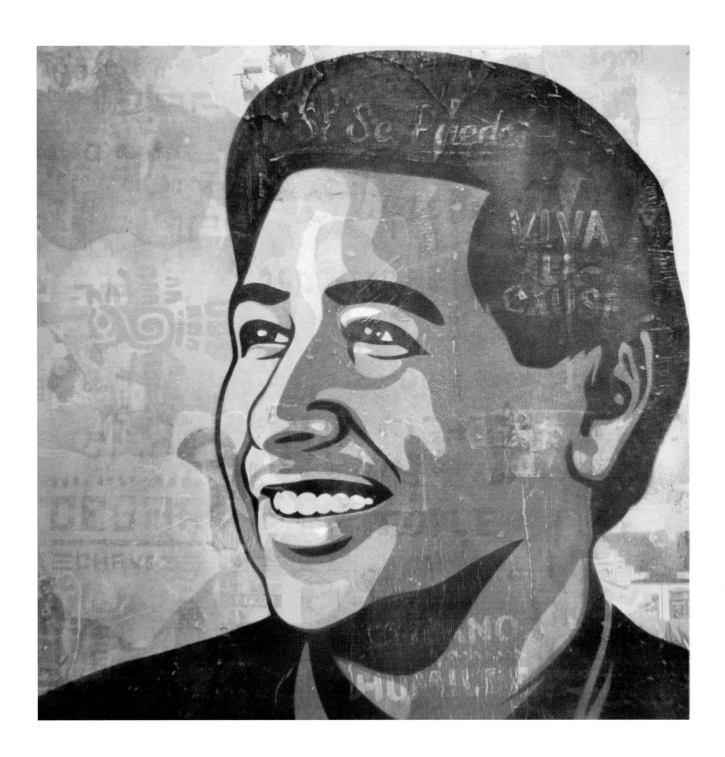

ABOVE
Ernesto Yerena
Cesar Chavez, **2009**
Mixed media on wood
24 x 24"

OPPOSITE ABOVE
Karen Wippich
Tru–Health Reform, **2009**
Acrylic paint and silk screen
on wood panel
29 x 24"

OPPOSITE BELOW
Charles Becker
Say It Out Loud, **2009**
Paintbrushes, steel, plastic,
adhesive
32 x 16½ x 24"

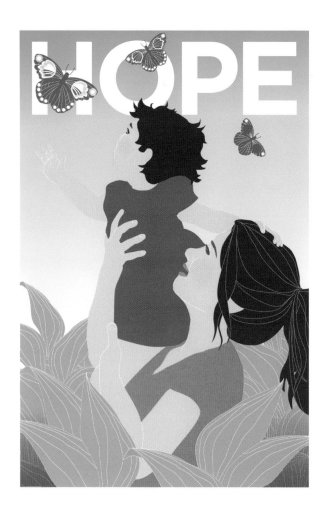

AMY MARTIN

"I was contacted by *Manifest Hope* after one of the
producers saw a poster series I'd just completed for
826LA (a non–profit that provides writing workshops
and after–school tutoring to kids) hanging in the
window of the Time Travel Mart in Echo Park. They had
been really happy with the way the Shepard Fairey
print was drawing attention in younger, urban neigh-
borhoods and wanted something that would communi-
cate more strongly to women—specifically women in
the Midwest, where I'm from.

I was really attracted to Obama's positions on environ-
mental stewardship, strong families, and education,
and I knew I wanted to weave those in somehow. As
soon as the CHANGE theme was brought up, I thought
of butterflies (perfect, natural symbols of metamor-
phosis, progress, possibility, and grace) and babies,
and how my friends in Michigan would take their kids
outside and lift them high up in the air so they could
grab apples from the trees. It was such an optimistic
image, and really captured for me the better world
that we want our kids to have, and the kind of support
and love the creation of that world requires. I do think
that Obama's campaign was about lifting people up—
not just people in our own families and neighborhoods,
but everyone. Our strength as a nation is dependent on
the strength of our families and communities.

I think it's really crucial that artists get outside of our-
selves and involved in causes we care about—it's im-
portant for everybody to participate. Some incredible
art came out of *Manifest Hope*, and I feel tremendous-
ly lucky that I had the opportunity to help out in this
way, but everybody who helped was essential, whether
they were phone-banking or going door-to-door. De-
mocracy is an active process, not just something that
happens on C–SPAN. Hopefully some people got to
know their neighbors a little better, and will continue
to stay active. There's certainly more work to do."

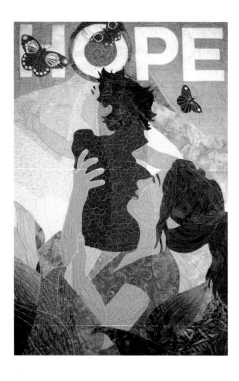

ABOVE
Margaret Cusack
Country Celebration, **1986**
Quilted fabric
29 x 22"

OPPOSITE ABOVE
Amy Martin
Hope, **2008**
Screen print on paper
24 x 36"

OPPOSITE BELOW
Julianne Walther
Hope in Cotton, **2008**
Cotton and thread quilt
24 x 36"

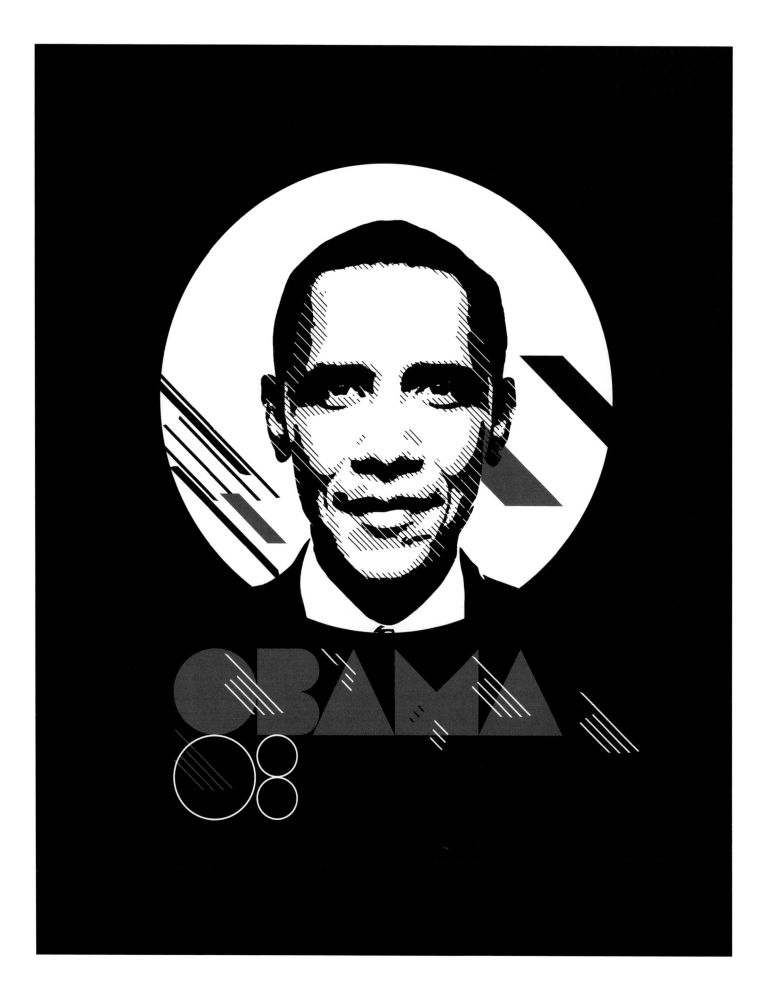

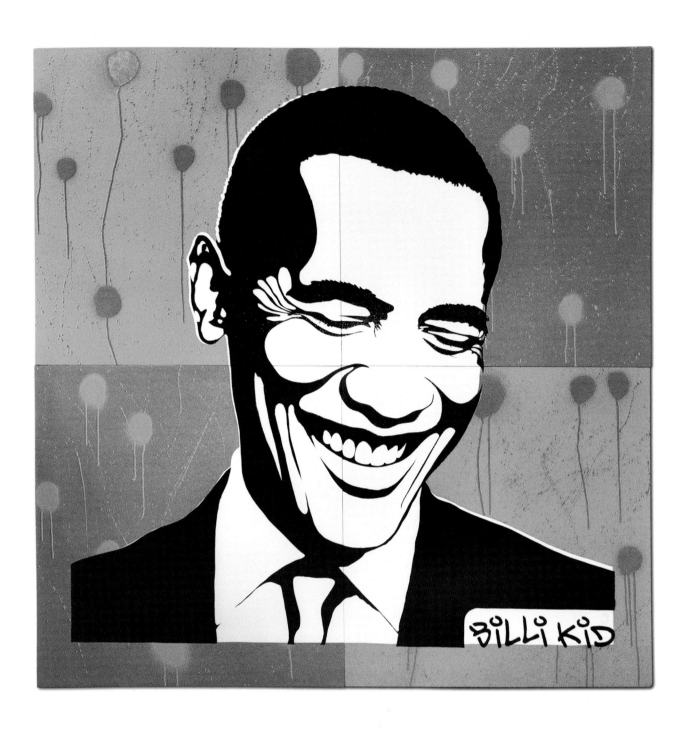

ABOVE
Billi Kid
Manifest Hope Obama, **2009**
Spray paint on panel
48 x 48"

OPPOSITE
Thomas Brodahl
Obama 08–Vote Hope, **2008**
Paint on wood
30 x 60"

129

ABOVE
Alexis MacKenzie
Lady Liberty: Old Glory, **2008**
Collage on antique paper
11 x 14"

RIGHT
KC Willis
Old Hope and Glory, **2008**
New and vintage fabrics
48 x 30"

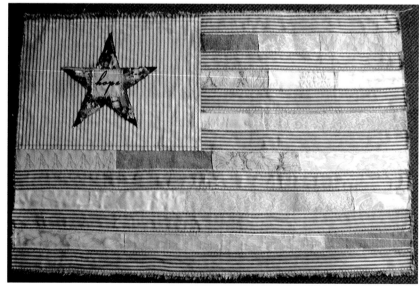

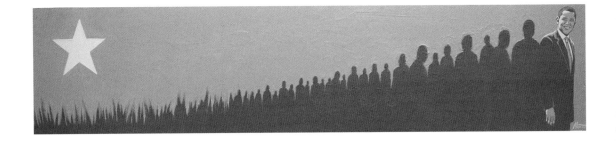

TOP
Yvonne Boogaerts
Change Starts at Home, **2009**
Acrylic on panel
24 x 24"

MIDDLE
Michael Leavitt
MoveOn a Little Green
from a Lot of People, **2008**
Acrylic paint on the back of
a plastic McCain campaign sign
44 x 11"

RIGHT
Kate Luscher
Madrugada, **2008**
Etching, aquatint, and drypoint
on paper
30 x 22"

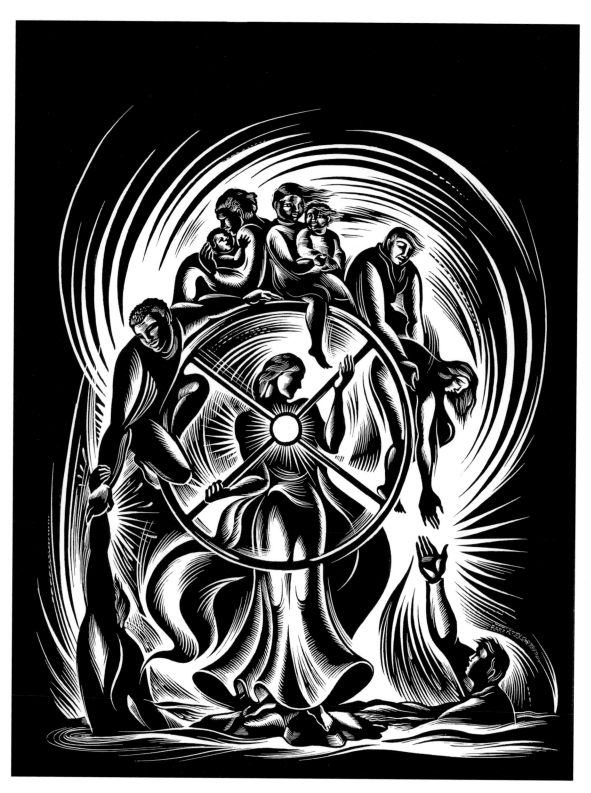

Cathie Bleck
Unlimited Love, **2008**
(from the collection of Gino Joukar)
Ink on scratchboard
14 x 18"

CATHIE BLECK

"All of us have points in our lives where we are inspired by heroic deeds, and have experienced periodic heroism in our own actions. When we overcome difficult challenges and succeed through good, yet difficult choices, it is in those experiences that one develops an association with sometimes abstract, symbolic, and mythic images. Powerful art often captures and reflects these ideas and symbols and serves as a tool by providing a feeling or emotional response that is necessary to translate common 'humankind' experiences, thus breaking some of the barriers that exist in communication. Art inspires us to both remember and strive to serve our greatest potential, individually as well as a community, so that we may develop a universal language in order to confront the issues that predict our own survival, now that humans have designed capabilities that effect every person on the planet.

My piece *Unlimited Love* represents the act of love, courage, and heroism, components necessary for progress and unity. Inspired by a recurring medieval symbol called the 'Wheel of Fortune,' it represents the concept that if we are attached as a community to the rim of the wheel of fortune, we will be either above going down or at the bottom coming up. We must stay on this rim of life together, uniting, going up or going down, moving through life and love for one another so that we can move forward. At the center glows a sun or moon symbolizing bliss, which is found through the affirmation of others and rejection of selfishness. The goal of understanding is not just to make this effort for a select groups benefit, but to advance a larger audience to gain useful knowledge."

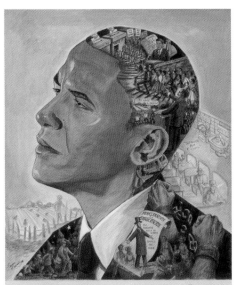

FOR ONE REASON THEY YEARNED - FOR ONE UNITED REPUBLIC

ABOVE

Mason Fetzer
The Road Ahead, **2009**
Hand—cut stencil and spray
paint on Plexiglas and wood
24 x 48"

LEFT

Larissa Marantz
This Moment, **2009**
Acrylic on canvas
24 x 30"

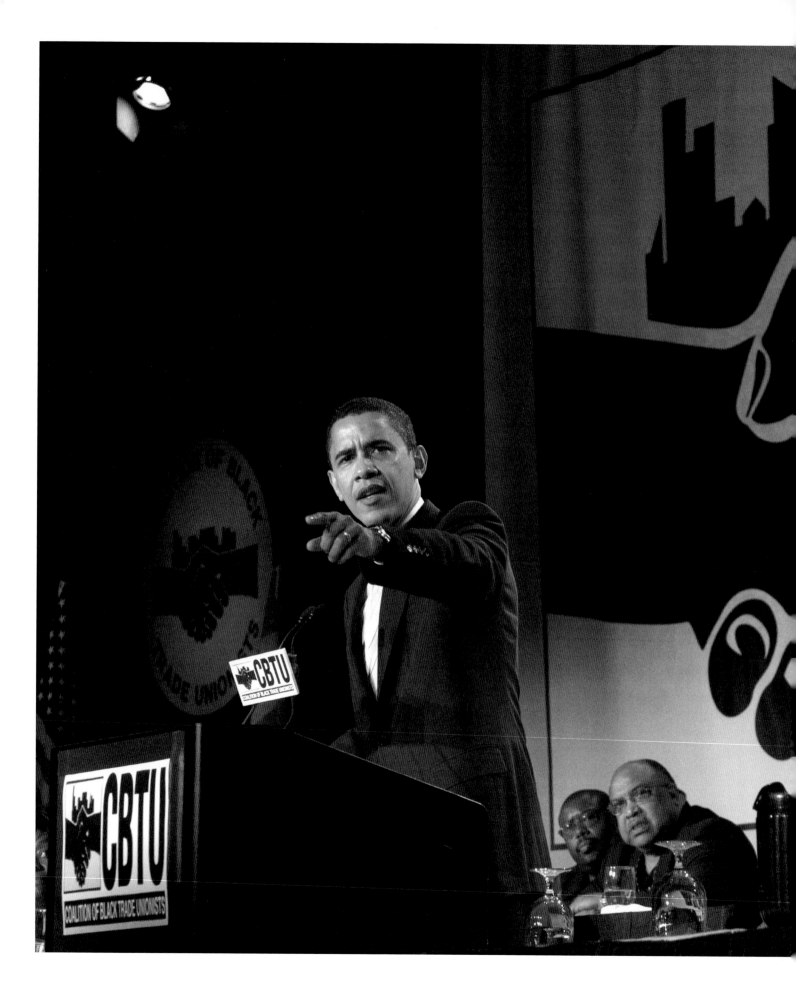

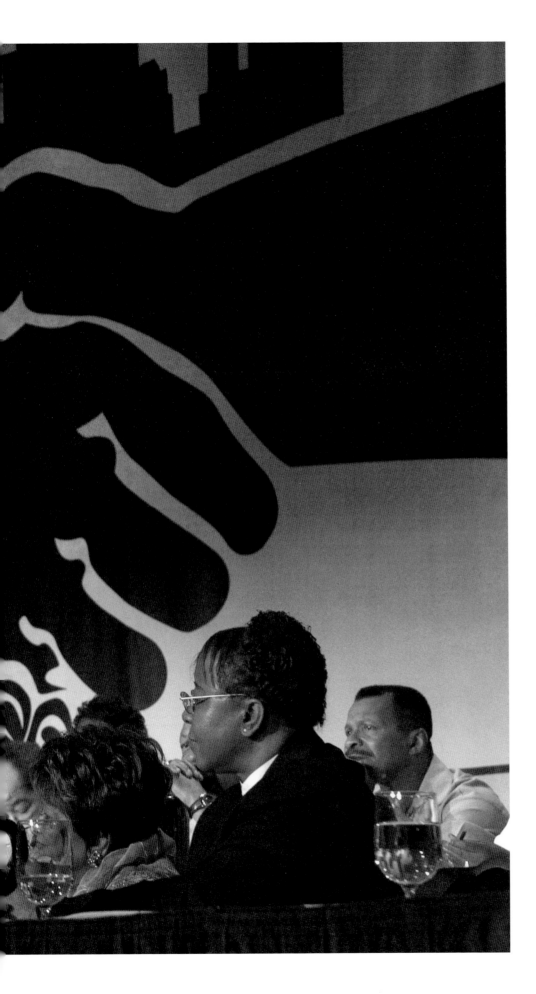

Sarah Hoskins
Coalition of Black Trade Unionists,
Sen. Barack Obama, 2007
Silver gelatin photographic print
14 x 11"

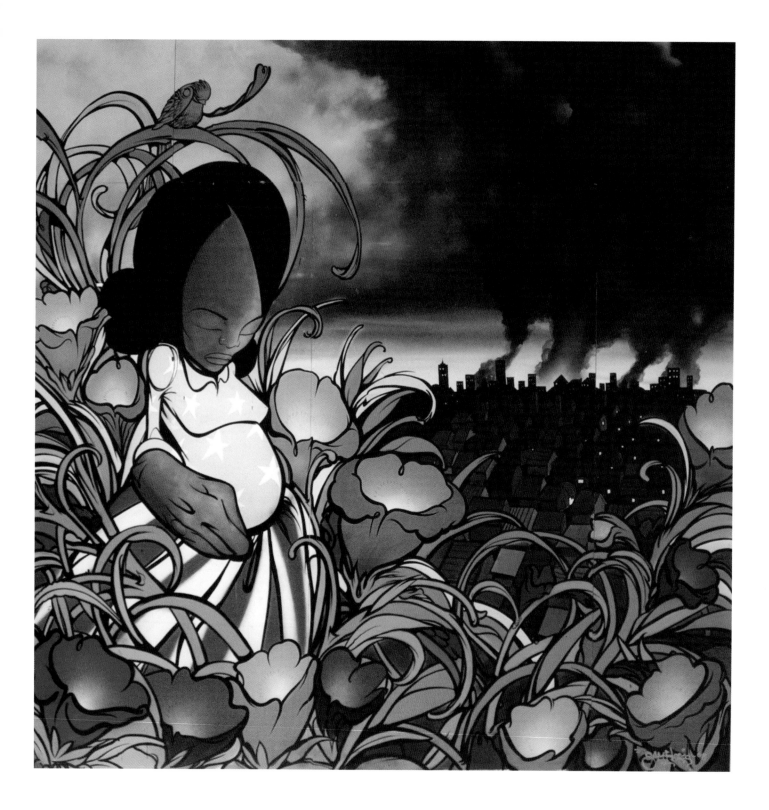

Sam Flores
New America, **2008**
Acrylic and aerosol
on Masonite boards
120 x 120"

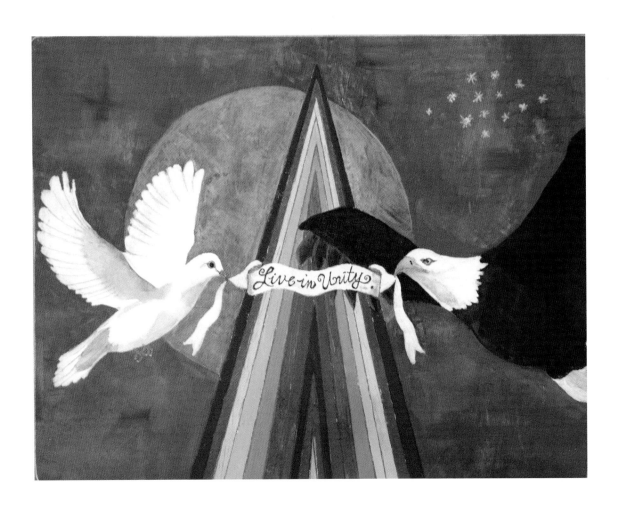

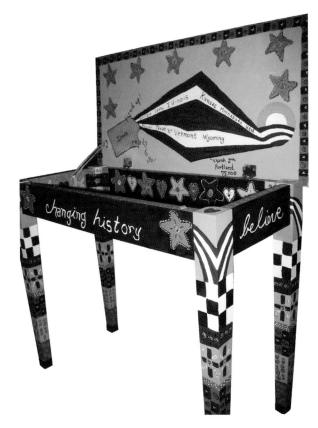

ABOVE
Lisa Congdon
Live in Unity, **2008**
Gouache on Masonite panel
14 x 11"

RIGHT
Mary K. Pyle
Play A New Tune, **2008**
Piano bench painted with acrylic paint
20 x 34"

137

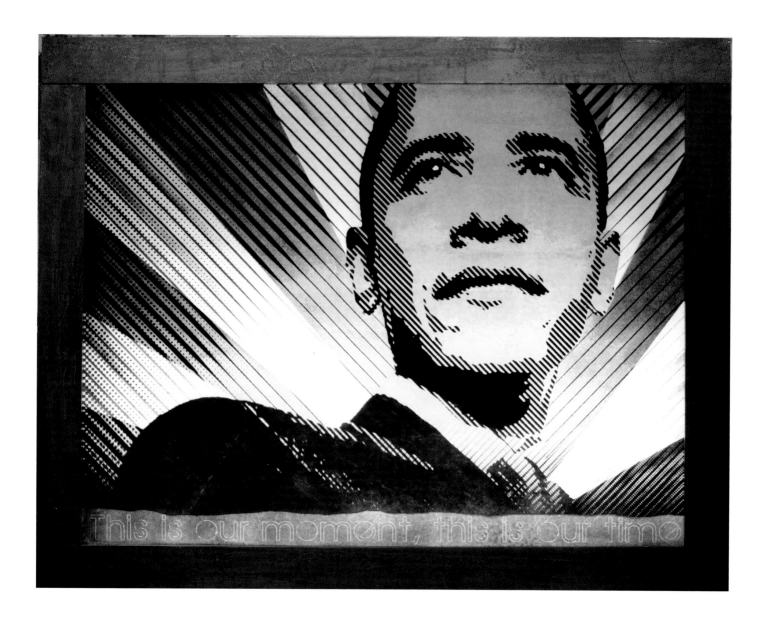

Eddie

Our Moment, Our Time, 2009

Copper, paper, shellac, wood,
Plexiglas, and fluorescent fixtures
40 x 54"

EDDIE

"This whole process has been extremely empowering. The grassroots movement surrounding Obama has reminded me of things I had long forgotten and, proven empirically, things I had always hoped were true. If you're someone who believes that there is no room for your voice in this democracy, I would ask you to raise your voice.

I assure you I am no one of affluence. I do not have friends in influential positions or a great deal of resources. I, like many of the artists, had only a strong desire to participate in the process and be heard. Our voices were heard. They filled the empty spaces of freeway columns and newspaper boxes, of boarded-up buildings and lamp posts. They spilled over onto T-shirts and stickers on cars. They resonated, and appeared on the pages of the *New York Times* and the *Chicago Tribune*. Our voices were broadcast into every home in America on CNN and the nightly news. We were heard in chorus in Denver and Washington DC. Our voices were heard, loud and clear."

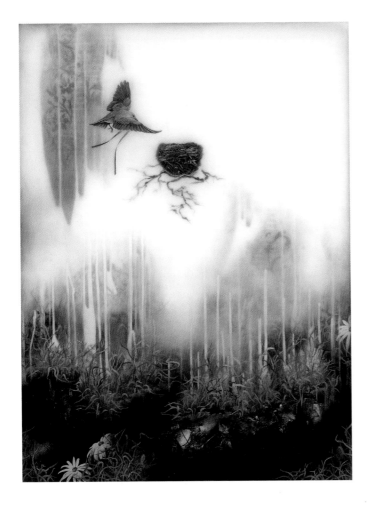

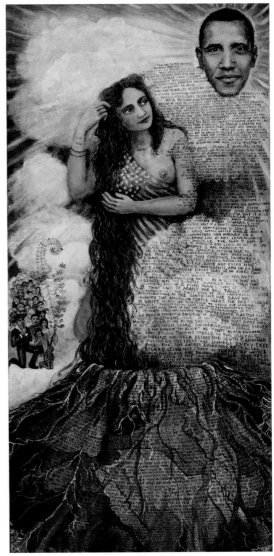

ABOVE LEFT
Regan Rosburg
Catharsis, **2009**
Oil paint, clear resin, trash, and
bird's nest on built wooden canvas
36 x 48"

ABOVE RIGHT
Irene Hartwicke Olivieri
Not a Minute Too Soon, **2008**
Oil on canvas
15 x 30"

RIGHT
Robyn Sand Anderson
Yearning, **2005**
Transparent watercolor on paper
11 x 15"

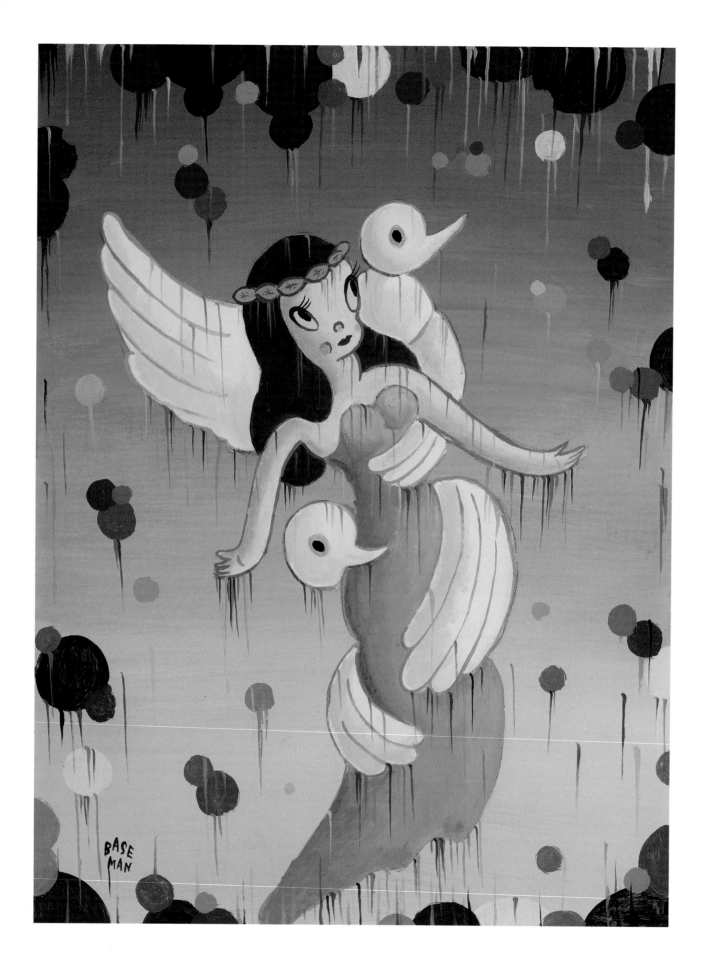

RIGHT
Cody Hudson
Hope, **2008**
Screen print on paper
18 x 24"

OPPOSITE
Gary Baseman
Hope, **2008**
Acrylic on canvas
26 x 32"

LEFT
Jude Buffum
The Games They Played, **2008**
Giclee print on canvas
10 x 10"

BELOW RIGHT
Zina Saunders
Looking Ahead, **2007**
Mixed media on watercolor paper
13 x 19"

BELOW LEFT
Jude Buffum
New Game, **2008**
Giclee print on archival artists paper
12¾ x 16½"

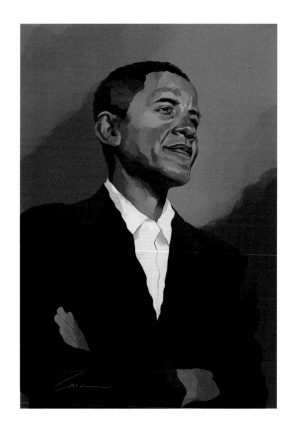

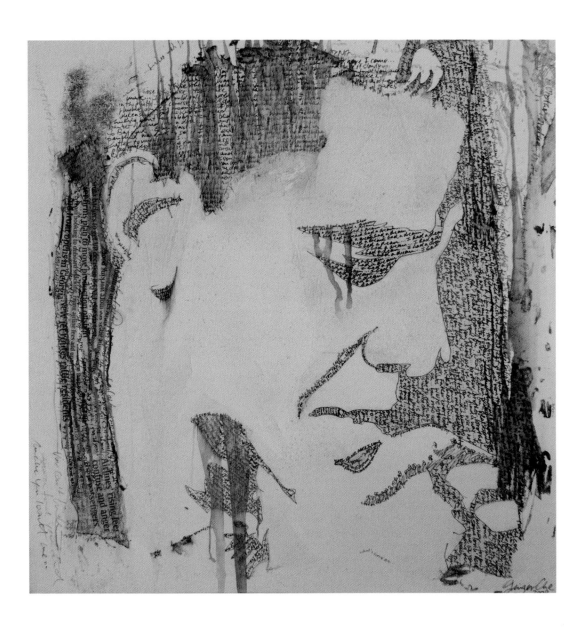

GINGER CHÉ

Ginger Ché
Ready or Not, **2008**
Mixed media on canvas
36 x 36"

"To me the words 'change' and 'hope' were strongly associated with Obama's campaign, steering me to embody our new leader with the ability to move us away from our current disastrous political situation to something more peaceful.

The black-and-white painting *What's Going On?* has the lyrics as handwritten text of Marvin Gaye's song in black as the shadow of Obama's portrait. It tells about Gaye's political concerns, the need for change in our world, and the necessity for actions of love, which are still current today. The hope for humankind to wake up and unite as one is the underlying message of this song as well as what Obama stands for. Having portrayed Obama in a thinking pose, I have instilled my energy for deep thought that comes from good intentions and love into our new president, knowing that the visual language is universal and most powerful.

As *Manifest Hope* means revealing a general feeling that a desire will be be fulfilled, many artists of this colorful country expressed their desire for a peaceful future in the most individual ways for the world to see. *Manifest Hope* has not only bundled the most free thinking energies of the creative world into one voice, it has also created inspiration for the non−believers."

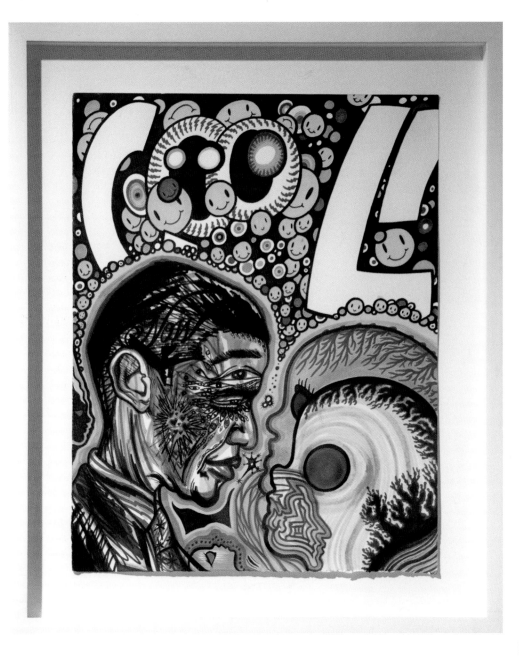

LEFT

Joseph "JK5" Aloi
*The Coolest Reborn Dialogue
(Obama and the Kids of the
World),* **2008**
Pen, ink, and marker on paper
12 x 16"

RIGHT

Chanel Kennebrew for Junkprints
Colored Fountain, **2008**
Giclee print
30 x 44"

OPPOSITE

Karla Mickens
Yes We Did, **2009**
Four-color silkscreen on paper
13 X 15"

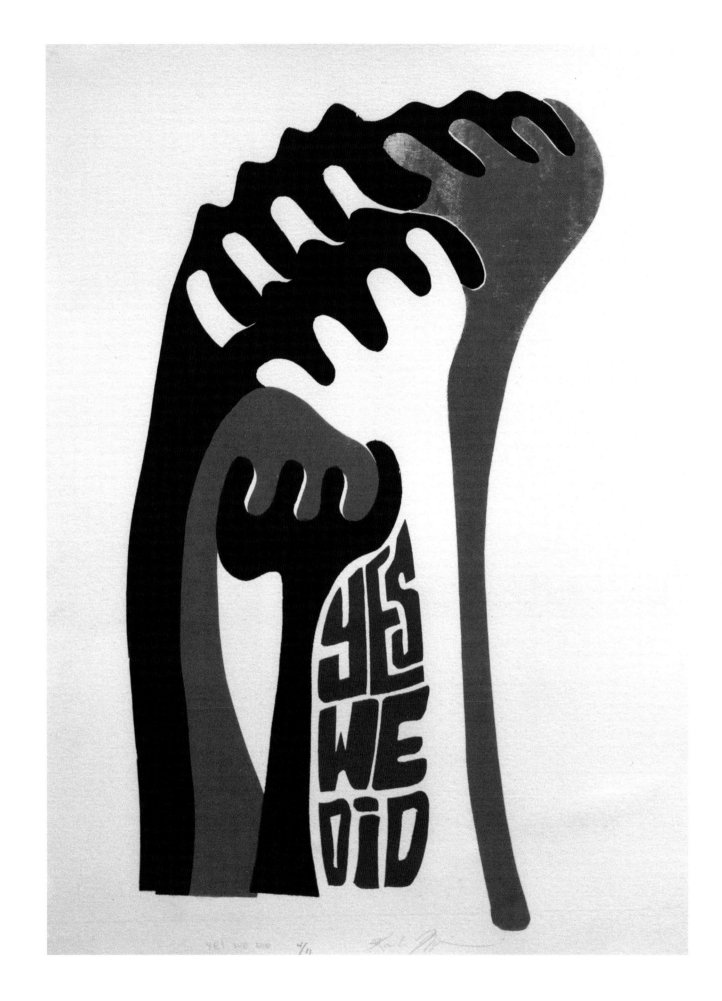

Lisa Marie Thalhammer
Michelle Robinson Obama, **2008**
Oil on canvas
67 x 86"

Trish Moreno
Unity, **2009**
Archival print on aluminum
30 x 45"

Eleanor Pigman
My Hope, **2008**
Lacy's stiff stuff, seed beads,
fabric flag, and thread
8¼ x 12"

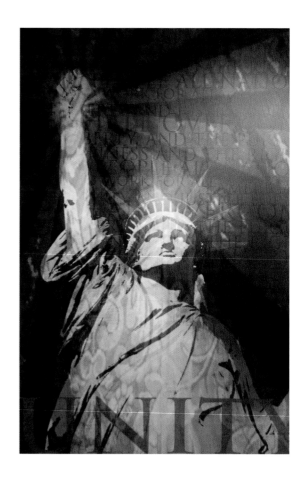

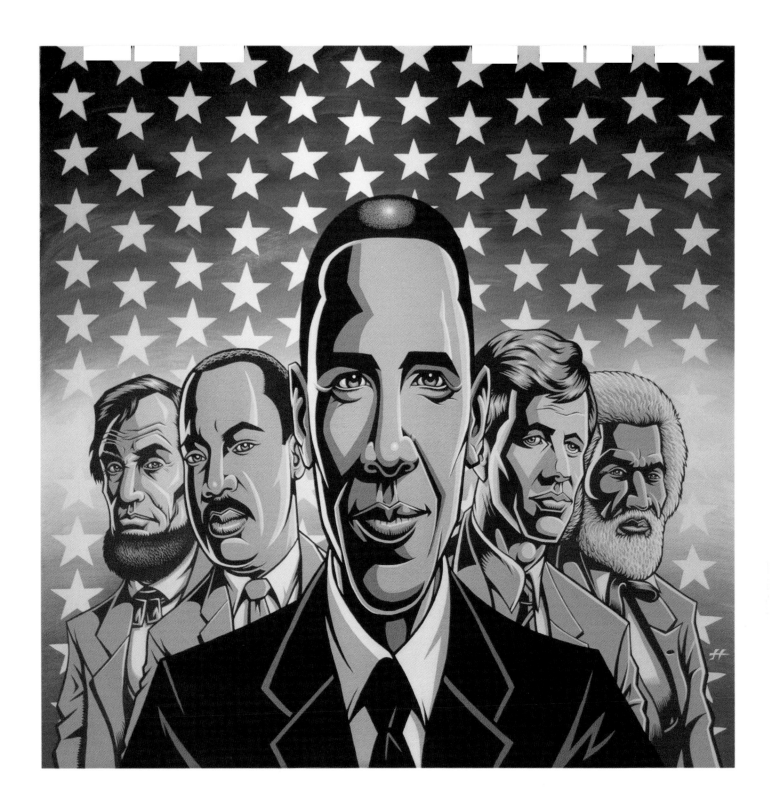

Justin Hampton
The Great Communicator, **2008**
Archival print and mixed media on panel
60 x 60"

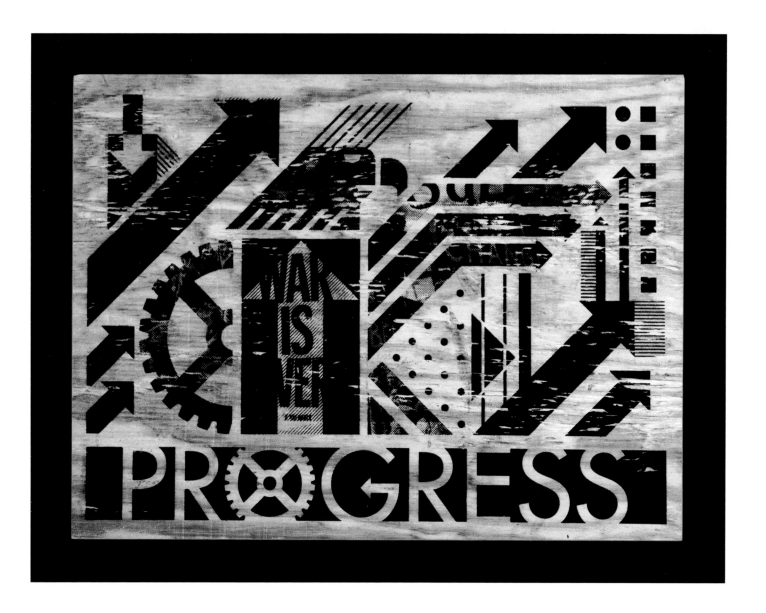

Casey Ryder
Progress, **2008**
Screen print on wood
27 x 20"

Casey Ryder
The New Ideal, **2008**
Mixed media on wood
24 x 24"

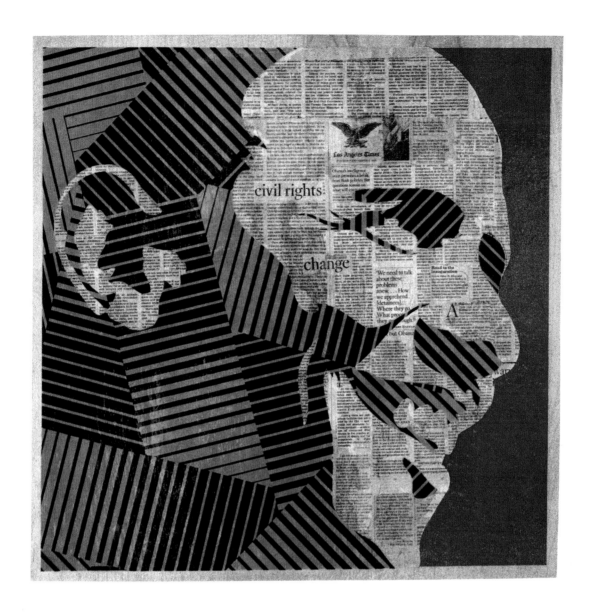

CASEY RYDER

"Typically, I'm one of those people who only get involved in politics on Election Day. I cast my vote. I get my sticker. Then I go home and watch Jon Stewart make fun of the whole thing. But all that changed with Barack. For the first time in my life, I didn't just root for the blue team to win. I actually got in the game. I worked a phone bank. I went to rallies. I passed out bumper stickers by the dozen. All because I finally felt like Barack was a politician I could be proud of. A leader like my parents remember in Kennedy. Or my grandparents remember in FDR. My art was simply born from that sense of pride. That connection. And it's just one more example of how Barack inspired me to do more than just check a few boxes every four years."

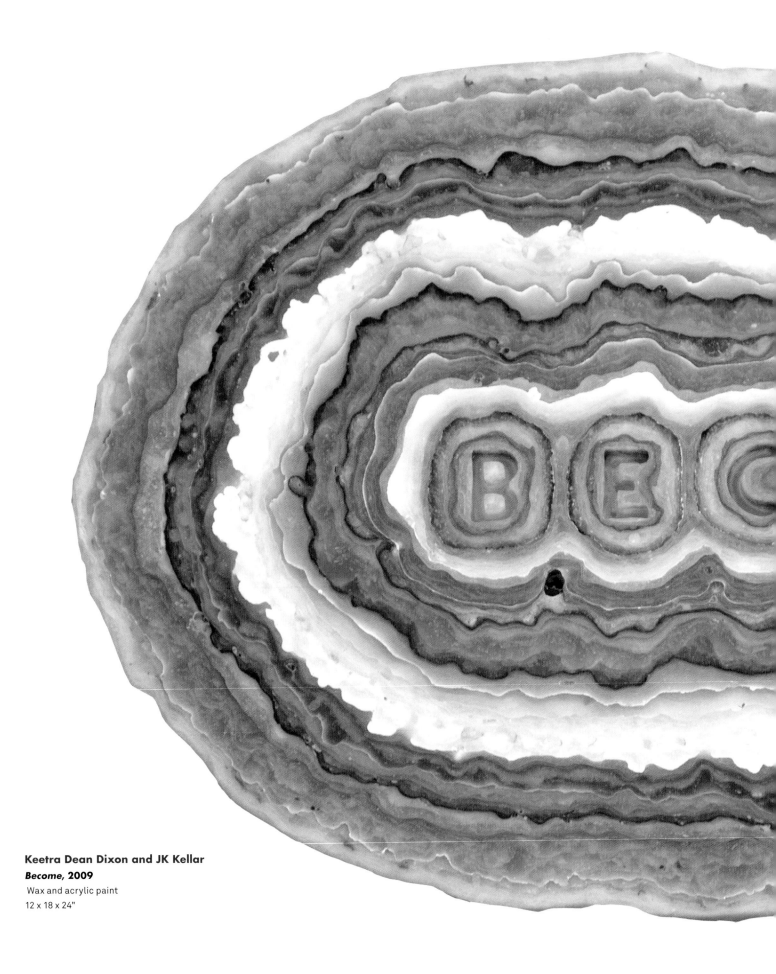

Keetra Dean Dixon and JK Kellar
Become, **2009**
Wax and acrylic paint
12 x 18 x 24"

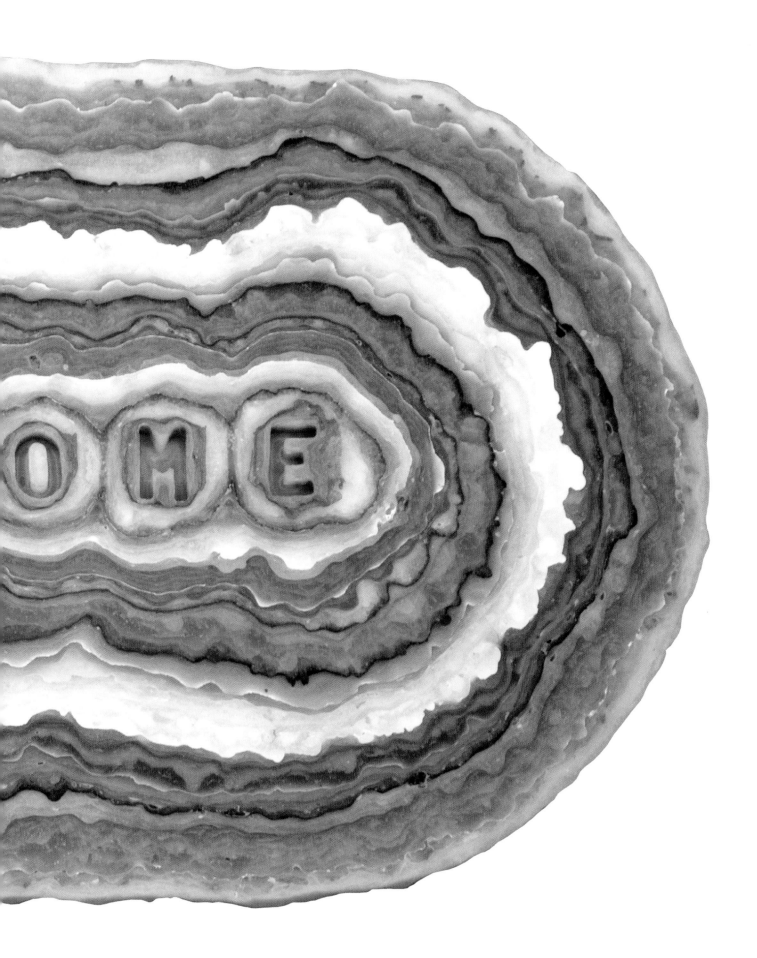

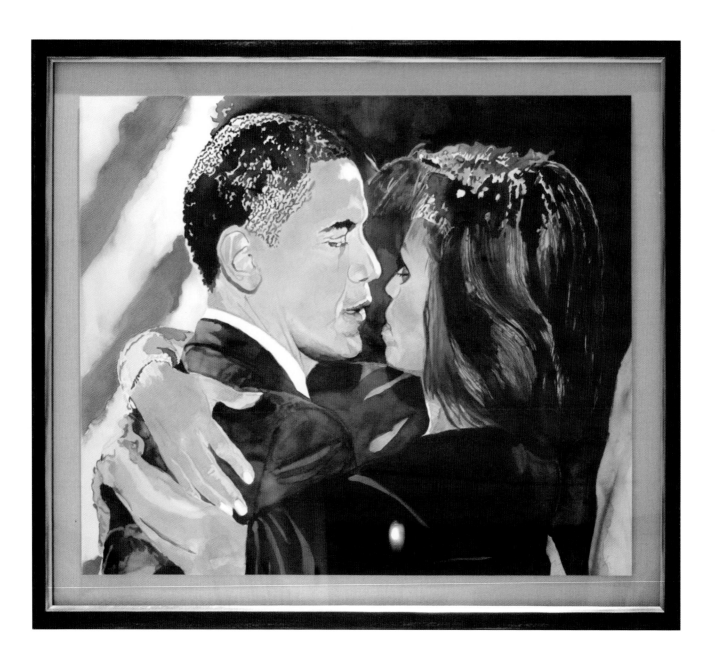

ABOVE
Judy North
Barack and Michelle, 2009
Watercolor on paper
52 x 42"

OPPOSITE TOP
Sueraya Shaheen
Right on Track, London
Tube, 2008
Cell phone photographs
38 x 10"

OPPOSITE MIDDLE
Ocean Clark
Obama Entrances
The Crowd, 2009
Acrylic on canvas
60 x 20"

OPPOSITE BOTTOM
Estevan Oriol
Pepper & Melanie –
LA River Love, 2007
Archival silver gelatin print
24 x 20"

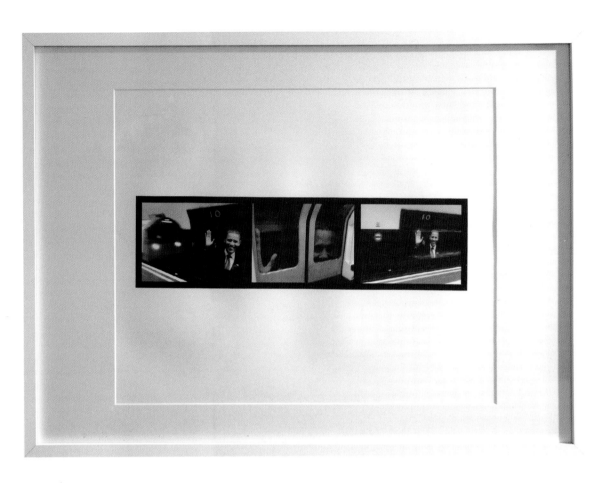

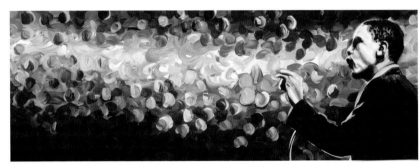

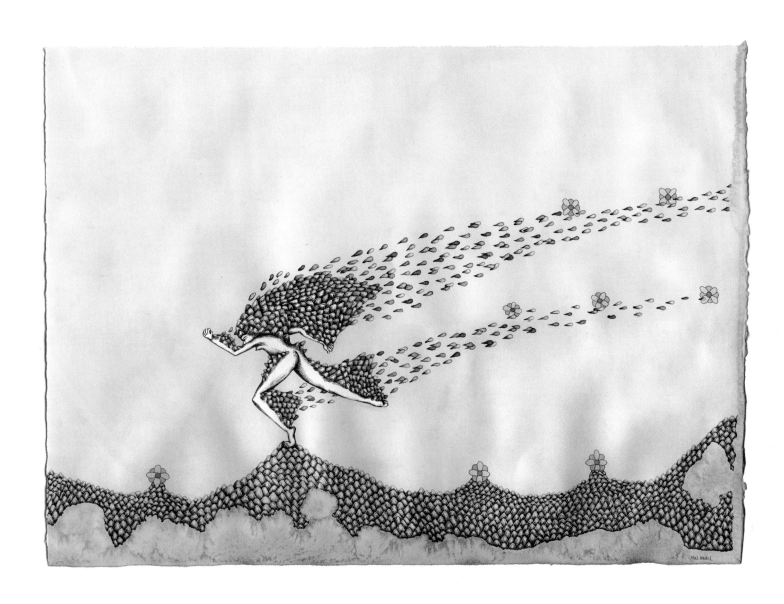

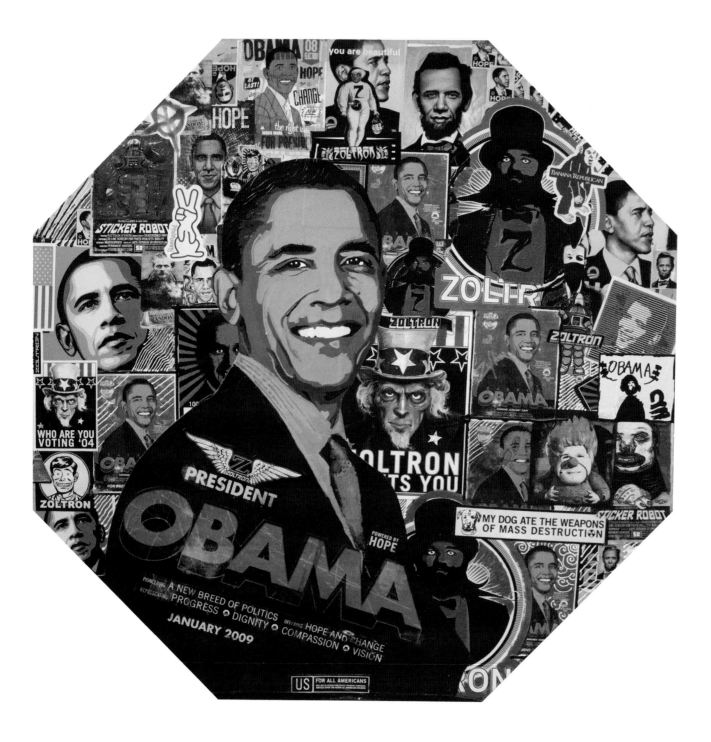

Zoltron

Meanwhile on the Corner of Limbaugh and O'Reilly..., 2009

Vinyl, aluminum, and acrylic
26 x 26"

ZOLTRON

"The fact that the Obama campaign has embraced and celebrated artists and musicians and, better yet, has been so supported by artists and musicians says a lot in itself. If you've been following this tidal wave of creativity, it's like we're in the middle of a modern-day, politically inspired, mini art renaissance."

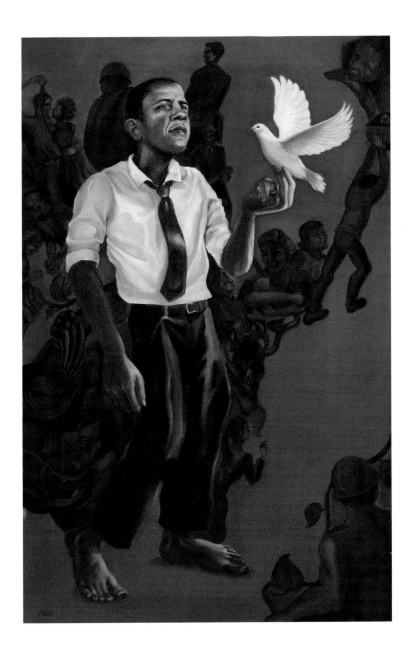

LEFT
Kate Crosgrove
Of the People, **2009**
Oil on Canvas
20 x 32"

BOTTOM RIGHT
Margaret Coble (aka Mags)
Believe (Blue), **2008**
Spray paint stencil and paint pen on paper
18 x 24"

BOTTOM LEFT
Chris Yates
*A Puzzle We Can Believe In
(Obama),* **2008**
Handmade painted wood jigsaw puzzle on painted MDF
12½ x 16"

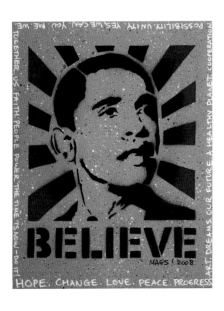

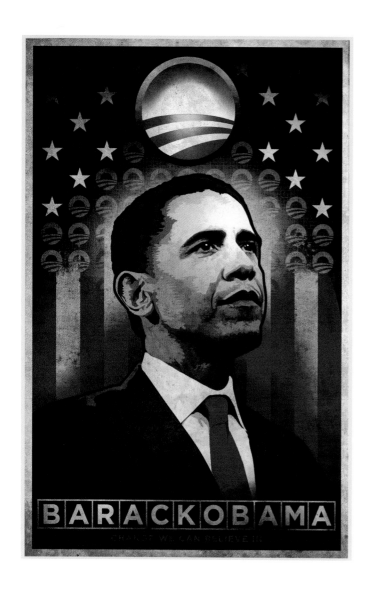

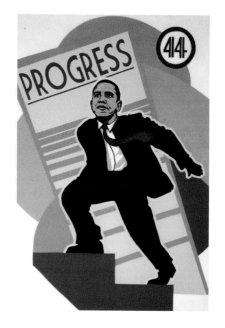

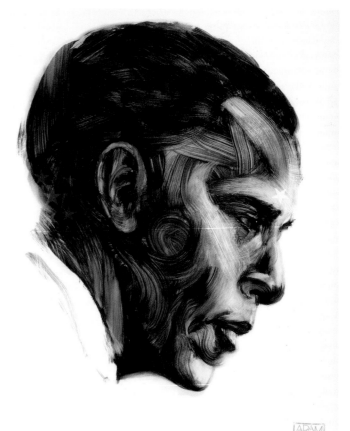

ABOVE
Christopher Cox
Change We Can Believe in, **2008**
Offset lithograph
24 x 36"

ABOVE RIGHT
Tim Conlon
44, 2009
Spray paint, paint marker,
and acrylic on canvas
24 x 36"

RIGHT
Adam Doyle
Veritas, **2008**
Oil and digital
13 x 19"

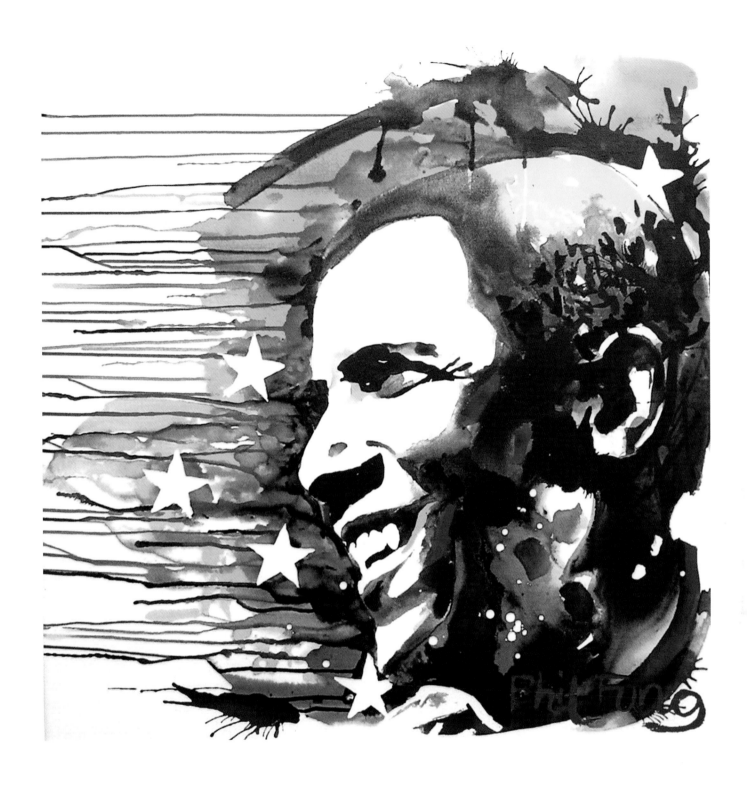

Phil Fung
Stars and Stripes, 2008
Watercolor and ink on canvas
36 x 36"

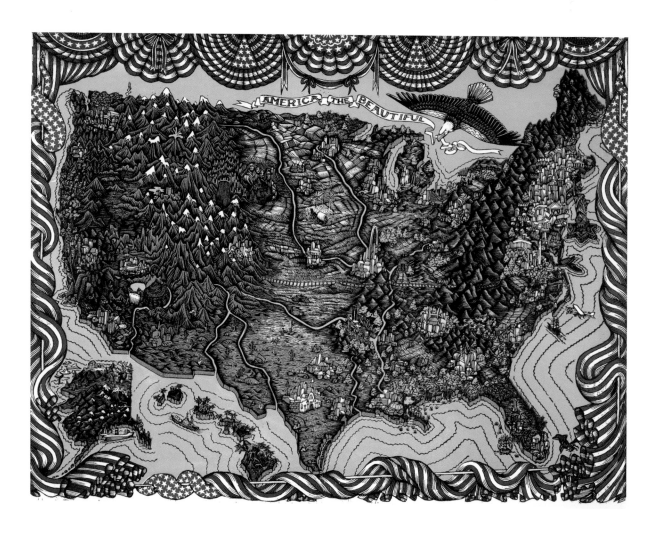

ABOVE
Tugboat Printshop
America the Beautiful, **2009**
Hand–colored woodcut
32 x 24"

RIGHT
Rick Griffith
Change, Hope, Progress, **2008**
Paint on three wood panels
36 x 24" each

OPPOSITE
Gene Mackles
Just Words, **2008**
Mixed media
15 x 21"

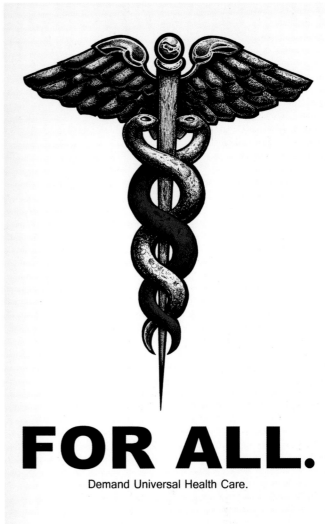

FOR ALL.

Demand Universal Health Care.

PATRICK MARTINEZ

"I believe knowing where we have been in the past as people gives us insight into our future. When we forget about figures like Martin Luther King then we cloud our future and become a little lost when it comes to progressing as people. It's important to remind ourselves of his accomplishments and his sacrifices. People forget because of the daily grind and their own struggles, which is understandable. This is why I honor him and his accomplishments with a portrait to remind everyone, not to mention myself, that we have come a long way. I only hope when someone sees my piece they can be reminded that King was the stepping stone for unity between people of different nationalities and color in the United States. He also helped pave the way for hope in our future."

ABOVE LEFT

Nicholas Rock
U NITE US, **2008**
Two-color screen print
24 x 36"

ABOVE RIGHT

Ian Simmons
caduceUS, **2009**
Ink on tracing paper
with digital coloring
11 x 17"

OPPOSITE

Patrick Martinez
MLK, **2005**
Mixed media on paper
22 x 30"

ABOVE
Melanie Reim
The Obama Wave, 2008
Charcoal and oil on paper
26 x 14"

RIGHT
**Shannon Bonatakis
and Josh Holland**
Hope, 2008
Acrylic on canvas
19½ x 25½"

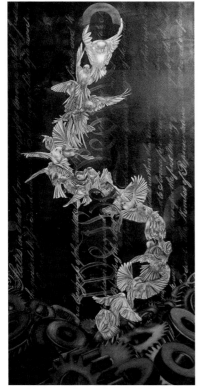

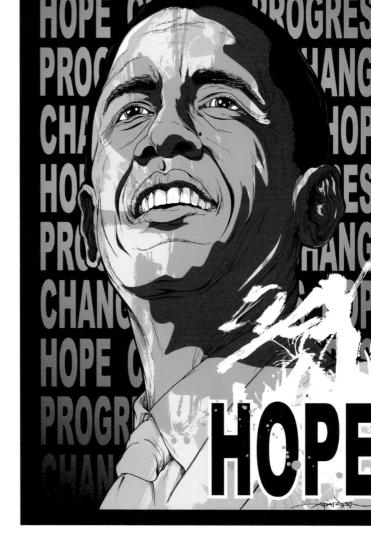

ABOVE LEFT

Jason Garcia

*The Past Inside
the Present,* **2008**

Oil on canvas

30 x 60"

ABOVE RIGHT

Alex Pardee

*Obama x Alex Pardee x
Upper Playground,* **2008**

Screen print on paper

18 x 24"

LEFT

Rostarr

*Vitruvian Brush Series I:
Winds Of Change,* **2009**

Acrylic polymer on canvas

80 x 54"

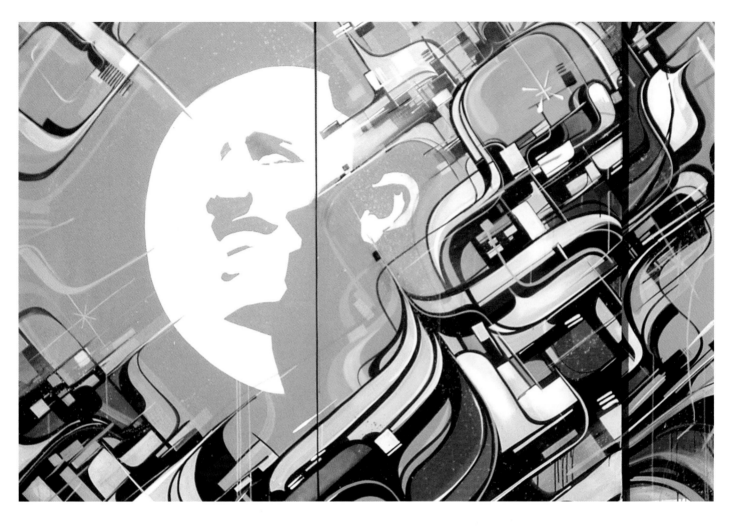

KOFIE

"I was given the opportunity to creatively contribute to Barack Obama's campaign and didn't give it a second thought. The fact that an artist like myself even lands on Obama's radar is an honor and speaks to exactly why Obama has my vote. Do you think any other candidate has a mural from an artist like me in their headquarters?"

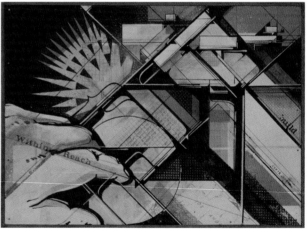

TOP
Kofie
California Has Hope, **2008**
Acrylic paint on canvas panels
60 x 36"

ABOVE
Kofie
Within Reach, **2009**
Found paper, watercolor, ink, gel transfers, and pencil on wood panel
20¾ x 15"

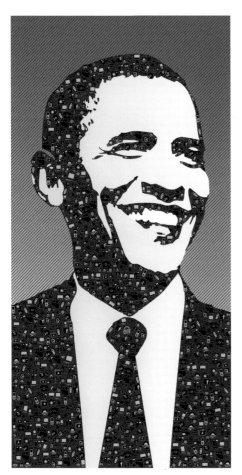

LEFT
James Widener
Hopefully Hopeful, 2009
Digital print mounted on wood
48 x 84"

BELOW
Jovi Schnell
Untitled, 2009
Acrylic gouache on wood collage
18¼ x 21"

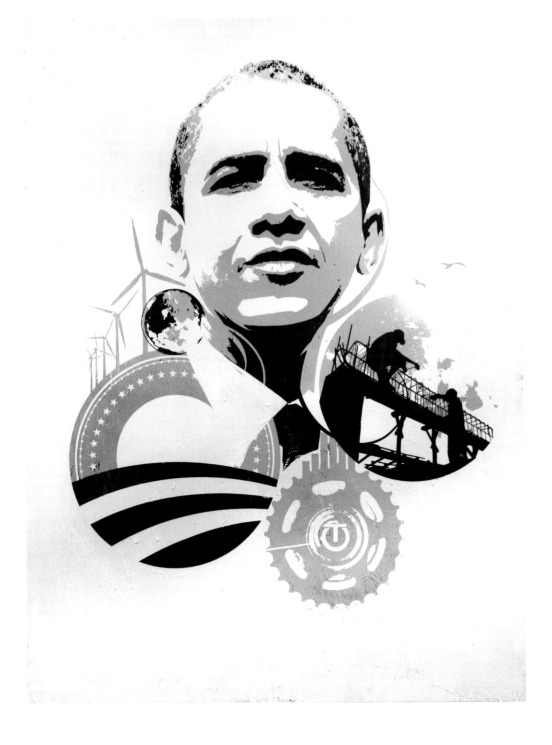

TES ONE

"I wanted to create something that reflected the hope and inspiration I feel in the election of Barack Obama and the workforce, technology, and determination that will lead us to progress. *Change We Made* is my tribute to Barack Obama and to the grass roots movement of the people who support our new president."

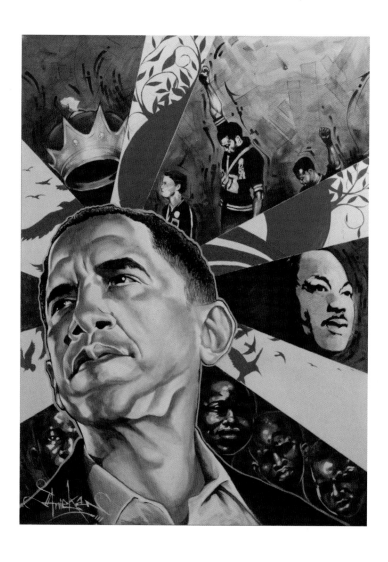

LEFT

Aniekan Udotio (AM Radio)
Here, **2008**
Acrylic on canvas
36 x 48"

BELOW

Derek Gores
For All Americans, **2009**
Collage on canvas
24 x 24"

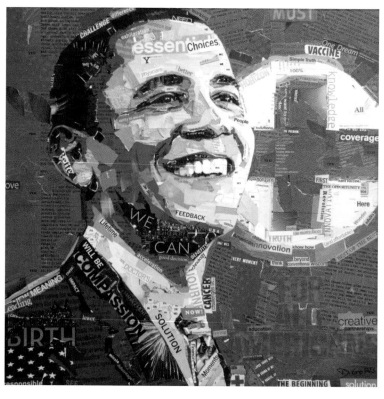

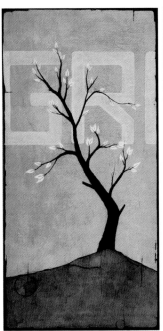

ABOVE
The Protist
Regrowth, **2009**
Mixed meda on canvas
30 x 15"

LEFT
Mark Jenkins
Global Mentality, **2009**
Mixed media
12 x 28 x 73"

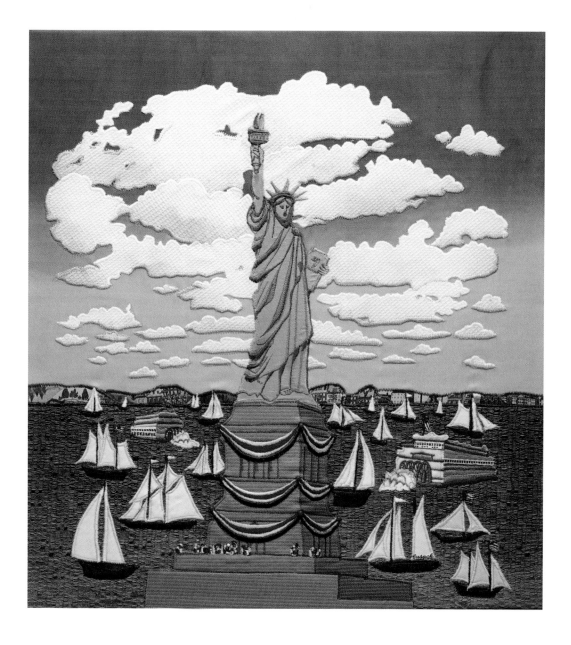

LEFT

Margaret Cusack
Statue of Liberty, 1985
Quilted fabric
16 x 17"

BELOW

Max Ginsburg
Flag Vendor, 2002
Oil on stretched canvas
60 x 42"

OPPOSITE

Michael Cuffe
The Hopeful Hearts Club, 2008
Acrylic and mixed media
on canvas
24 x 36"

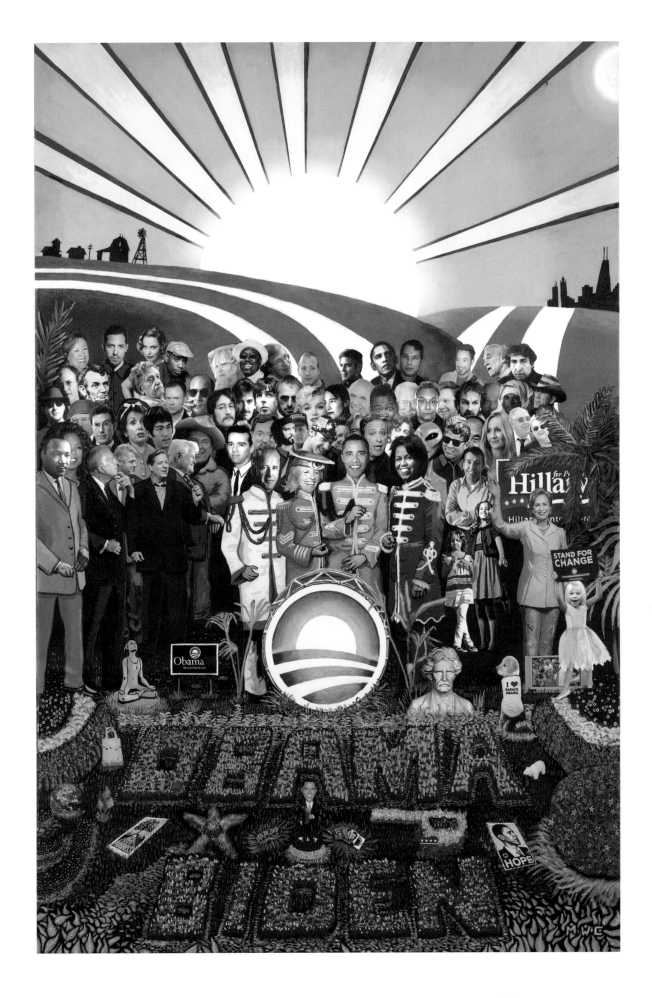

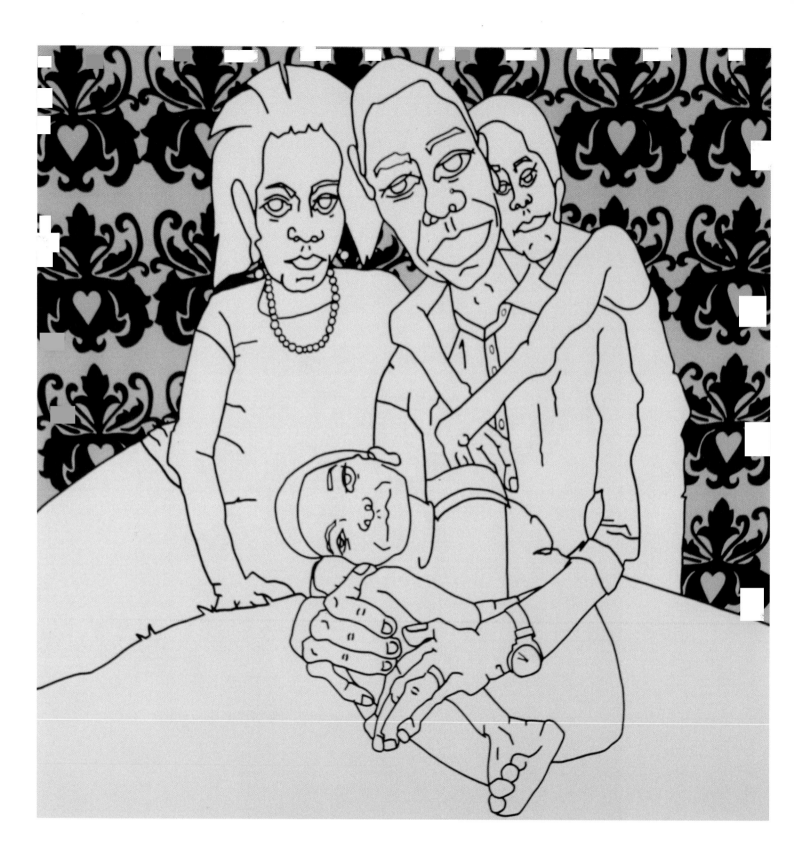

174

Tatyana Fazlalizadeh
Is He Black Enough?, **2008**
Oil on canvas
18 x 24"

Sebastian Martorana
Homeland Security Blanket, **2008**
Marble
24 x 24 x 24"

Catherine Foster
Weaving of Hope,
Peace and Joy, **2008**
Embossed copper and
aluminum, with words of hope,
peace, and joy
42 x 24"

Decoy
La Familia – Golden, **2009**
Acrylic, latex, and oil paint on canvas
60 x 60"

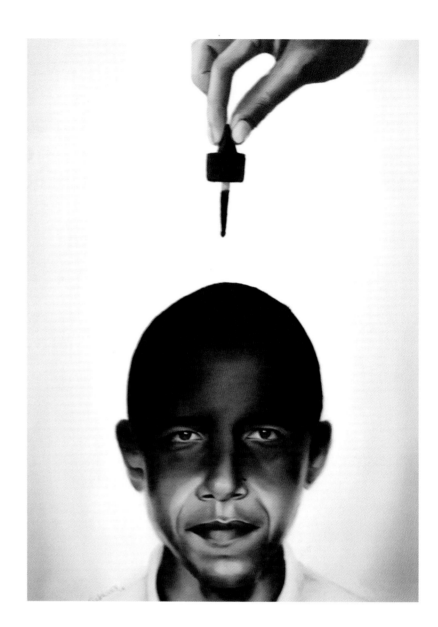

CENSUS 2008

DAN Funderburgh

LEFT

Dan Funderburgh
Census, **2009**
Three-color letterpress on
Speckletone archival paper
13 x 20"

OPPOSITE ABOVE

Shawn Hazen
United Change Poster, **2008**
Archival inkjet print
18 x 24"

OPPOSITE BELOW

Shawn Hazen
United Change Installation, **2008**
Screen print on aluminum
8 x 8" each letter

DAN FUNDERBURGH

"This is the first time in my life in which an election seemed truly pivotal. I've voted and campaigned before, but the combination of the utter dystopia brought on by the prior administration combined with the tantalizingly real offering of change offered by the Obama campaign meant that I had to do more than vote. For better or worse, the most I can do is make art, but I would be doing myself and my community a disservice if I didn't make art to raise money and awareness for what I believe—and from seeing all the other work that emerged from the campaign, it's inspiring to see a lot of other people felt the same way."

I am a strong believer in the separation of church and state... But what I also think is that we are under obligation in public life to **translate** our **religious values into moral terms that all people can share,** including those who are not believers**.**

Barack Obama

CNN YouTube Democratic Debate
July 23, 2007
Charleston, SC

Deroy Peraza

Rhetoric, **2008**

Series of six digital prints

24 x 36" each

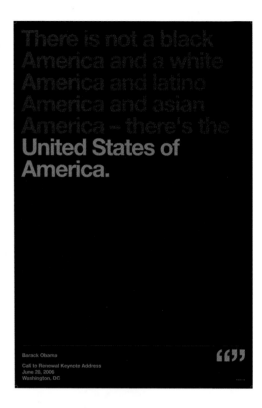

There is not a black America and a white America and latino America and asian America – there's the **United States of America.**

Barack Obama
Call to Renewal Keynote Address
June 28, 2006
Washington, DC

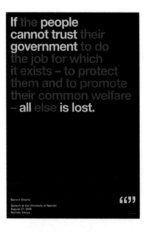

If the **people cannot trust** their **government** to do the job for which it exists – to protect them and to promote their common welfare – **all** else **is lost.**

Barack Obama
Speech at the University of Nairobi
August 27, 2006
Nairobi, Kenya

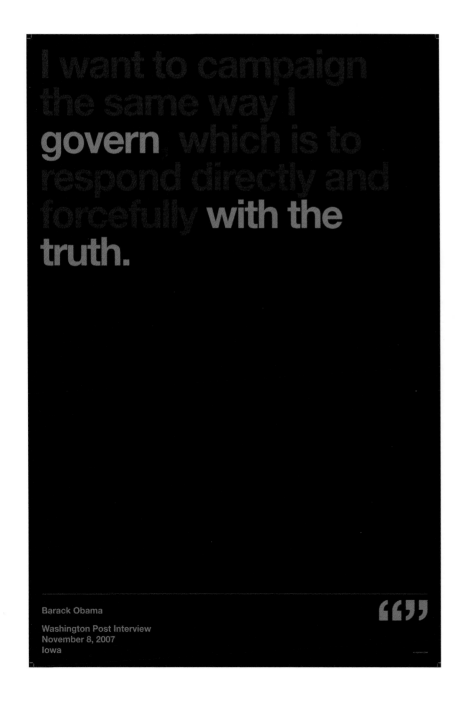

I want to campaign the same way I **govern**, which is to respond directly and forcefully **with the truth.**

Barack Obama

Washington Post Interview
November 8, 2007
Iowa

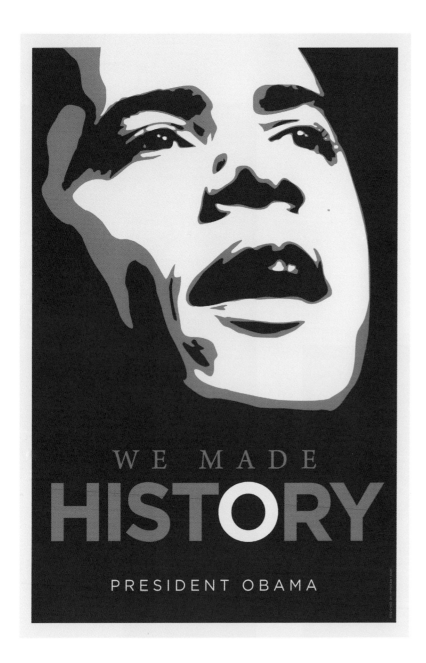

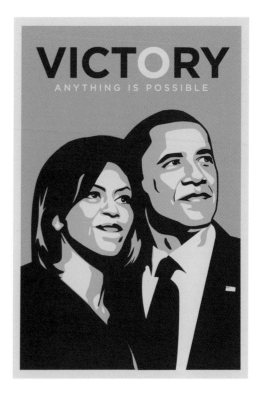

LEFT

Deroy Peraza
We Made History, **2008**
Silkscreen print
40 x 56"

BELOW

Deroy Peraza
Victory: Anything Is Possible, **2008**
Screen print
40 x 56"

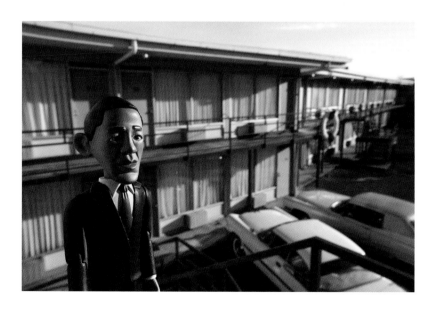

ABOVE
Deroy Peraza
American Evolution, **2008**
Digital print on cotton fabric
96 x 63"

LEFT
Brian McCarty
Lorraine Motel, **2008**
Toy by Jason Feinberg of
Jailbreak Toys
17 x 11"

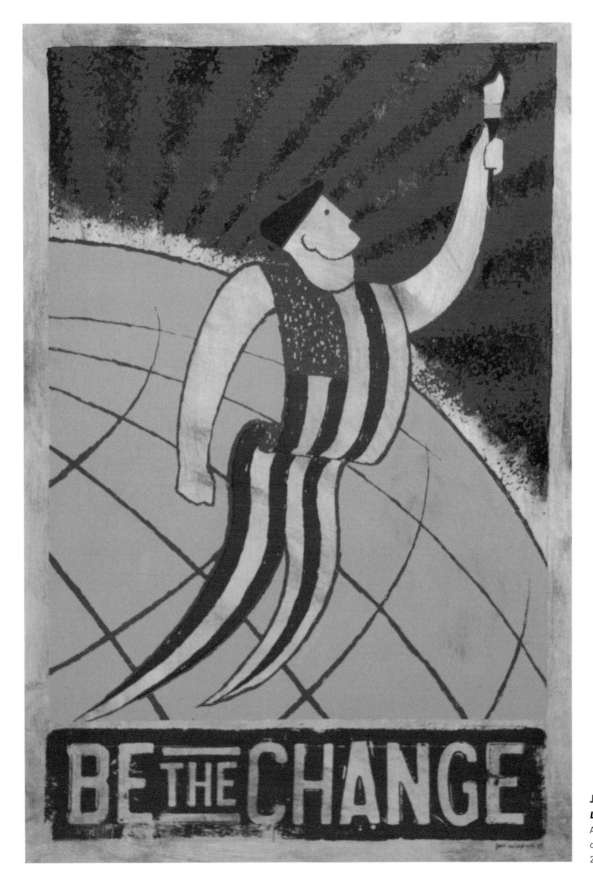

Jon Wippich
Lighting the Way, **2009**
Acrylic paint and silk screen
on wood panel
22 x 34"

ACKNOWLEDGMENTS

For us, it's hard to top something as impactful as *Manifest Hope*, where people witnessed firsthand the results of passion and creativity. The idea formulated and became a reality with the partnership and support of MoveOn.org. Without MoveOn's continual encouragement, support, guidance, vision, and love this book would have been possible. Laura Dawn and Ilyse Hogue were constant supporters and believers, and ultimately the Manifesters of a project and dream we had to create. We owe a tremendous amount of thanks to them, Eli Pariser, the entire staff of MoveOn.org, and their 5 million members who all partnered and helped produce *Manifest Hope.*

We cannot thank enough SEIU President Andy Stern, SEIU Secretary Treasurer Anna Burger, Jon Youngdahl, Stephen Chavers, Wyatt Closs, and the amazing Michelle Miller for their tremendous support.

The revolutionary inventiveness of artists such as David Choe, the Date Farmers, Ron English, Sam Flores, Maya Hayuk, Scot Lefavor, and Michael Murphy resulted in works that seeped under the skin of patrons, leaving them with lasting personal connections to the movement. Connections that resonated because of the brilliance and intensity that makes up visionaries like Shepard Fairey, who taught us what collective action is, not as an abstract concept, but what it can mean when effectively implemented.

Then there were the people who were artists in their own right, though not in the conventional paint-and-pallet sense, who contributed their skills by capturing the exhibit in light and photos. Thank you for your images Jean Aw, Robin Bell, Emily Gomez, Daniel Mintz, Daron Murphy, Raymond Roker, Jensen Sutta, Lesly Weiner, videographer Danny Lee, and Kiki Lindskog of Carolux Lighting.

The sincerity and unwavering commitment from artists was equally matched by the volunteers, especially Malik Adunni, Bim Ayandele, Jeremy Burns, Cori Doherty, Sowaila Ghanizada, Richard Gould, Rick Griffith, Ken Harman Hashimoto, Nik Harrington, Veronica Jackson, Bena Larkey, Sebastian Martorana, Michael Pollack, Adrian Tucker, Brinsley Tyrrell, Will Suitts, Matt Wise, and Tan Wong. These volunteers acted as yet another energizing force that made *Manifest Hope* possible and, by extension, helped fuel the entire movement.

Thank you to Tiffany Caronia, Alanna Navitski, Julia Axelrod, and David Scharff of Evolutionary Media Group for holding down the fort. David Koenig, Elan, Danielle, and Jonah—for putting up with it all and always being home base. Joycie Dungca, Stephanie Schonauer, Olivia Perches, and the entire team at Obey Giant and Studio Number One who endured it all!

When partnerships are formed for an event founded on principles of inclusivity, mobilization, and progressivism, relationships develop into mutually esteemed appreciation, each group adding what the other lacked. *5280* magazine, Donae Burston and Kenny Mac of Belvedere, Philippe Lanier and Diane Debus of East Banc, Heinz Weber Inc., *Juxtapoz* magazine, Monster Media, Jean Aw at NotCot.org, Lorrie Boula and Shauna O'Brien of Soul Kitchen, Matt Revelli and the artists of Upper Playground, Raymond Roker of *Urb* magazine, Imeem.com, Soroush Shehabi and Michael Clements of *Washington Life*, Zoltron, Fenton Communications, the Duke Ellington School of Music, and Maria Teresa Petersen of Voto Latino.

Martin Irvine, Deb Everhart, Lauren Gentile, and Thomas W. Powell of Irvine Contemporary and Tom Horne from Andenken Gallery—who had no clue what they were getting themselves into when they signed up for *Manifest Hope* and proved to be gallerists of a caliber beyond our highest expectations—handled every challenge with complete poise and the utmost professionalism, charm, and competency.

The multiple partnerships surrounding the event highlighted its universality, enabling people to lend their public image to *Manifest Hope*. Celebrities, performers, and politicos who identified with our causes became motivated to contribute their talents. Thank you Mathew Caws, Cold War Kids, Clap Your Hands Say Yeah!, De La Soul, Rosario Dawson, Zooey Deschanel, Ben Gibbard, Santigold, Scott Goodstein, Heather Graham, Rilo Kiley, Jenny Lewis, Moby, Nada Surf, Gavin Newsom, Sarah Silverman, Silver Sun Pickups, Jeremy Sole, Michael Stipe, Michael Strautmanis, Chris Walla, David Washington, and DJ Z-Trip. And thank you to the *Manifest Hope* Art Contest judges who helped to bring public art into the gallery—Ross Bleckner, Robbie Conal, Laura Dawn, Anne Ellegood, Shepard Fairey, Eric Fischl, April Gornik, Eric Hilton, Van Jones, Spike Lee, Moby, Thurston Moore, Cydney Payton, David Rolf, Nancy Spector, and DJ Spooky.

A special thanks to a group of people, our angels, without whom Hope could have never Manifested: Jill Goldman, Vicki Kennedy, Wendy Riva, and our DC connect, Sarah Nixon—mothers, united by years of friendship and mobilized by Obama, who worked in the trenches together, alongside artists and volunteers, bringing with them George Morlsbarger, the truest of Obama supporters, who to this day proudly (and bravely) wears the first edition HOPE shirt made out of cotton so itchy it borders on abrasive.

And finally, we are grateful for the support and guidance of agent Ryan Fischer-Harbage, who negotiated the waters for us to make this book come true. Publisher of Abrams Image, Leslie Stoker, head of publicity for Abrams Image, Claire Bamundo, Maxine Kaplan and Jacquie Poirier from the Abrams Image production department, and the ever relentless and zestful Jonathan Stein, who was determined to edit his first book!

Our sincerest thanks and gratitude to all those involved in *Manifest Hope*, from artists to visitors—your contribution to the galleries manifested change.

Jennifer Gross, Yosi Sergant, Megan Rollins
Evolutionary Media Group

Editor: Jonathan R. Stein
Design: Studio Number One
Production Manager: Jacqueline Poirier

Library of Congress Cataloging-in-Publication Data

Art for Obama : designing manifest hope and the campaign for change / edited
by Shepard Fairey and Jennifer Gross.
 p. cm.
 ISBN 978-0-8109-8498-1 (Harry N. Abrams, Inc.)
 1. Obama, Barack—Posters. 2. Presidents—United States—Election—2008. 3.
Obama, Barack—Portraits. 4. Political posters, American. 5. Fairey, Shepard. I.
Fairey, Shepard. II. Gross, Jennifer (Jennifer Lynn) III. Title: Designing manifest
hope and the campaign for change.
 E906.A78 2009
 760'.04493249730931—dc22
 2009023441

Printed and bound in the U.S.A.
10 9 8 7 6 5 4 3 2 1

Abrams Image books are available at special discounts when purchased in
quantity for premiums and promotions as well as fundraising or educational
use. Special editions can also be created to specification. For details, contact
specialmarkets@abramsbooks.com, or the address below.

THE ART OF BOOKS SINCE 1949
115 West 18th Street
New York, NY 10011
www.abramsbooks.com